ENCHANTED WORLD

THE ART OF ANNE SUDWORTH

COMMENTARY BY JOHN GRANT

Paper Tiger

This book is dedicated to my sister, Deborah.
In all the world I could never find another friend like you.
ANNE SUDWORTH

First published in Great Britain in 2000 by Paper Tiger
64 Brewery Road
London
N7 9NT
www.papertiger.co.uk

A member of **Chrysalis** Books plc

Distributed in the United States and Canada by Sterling Publishing Co.,
387 Park Avenue South, New York, NY 10016 USA

9 8 7 6 5 4 3 2

British Library Cataloguing-in-Publication Data:
A catalogue record for this book is available from the British Library.

ISBN 185585 7685 (paperback)

Designer: Malcolm Couch

Reproduction by Global Colour, Malaysia
Printed and Bound by Craft Print International Ltd, Singapore

The official Anne Sudworth website is: www.annesudworth.co.uk

CONTENTS

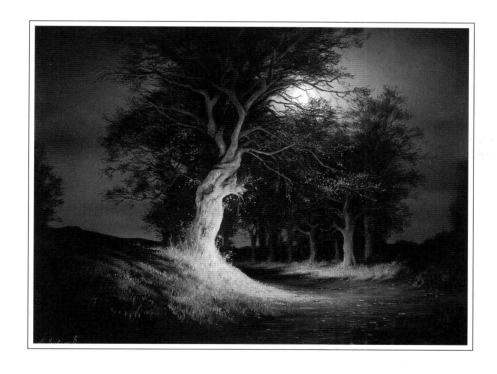

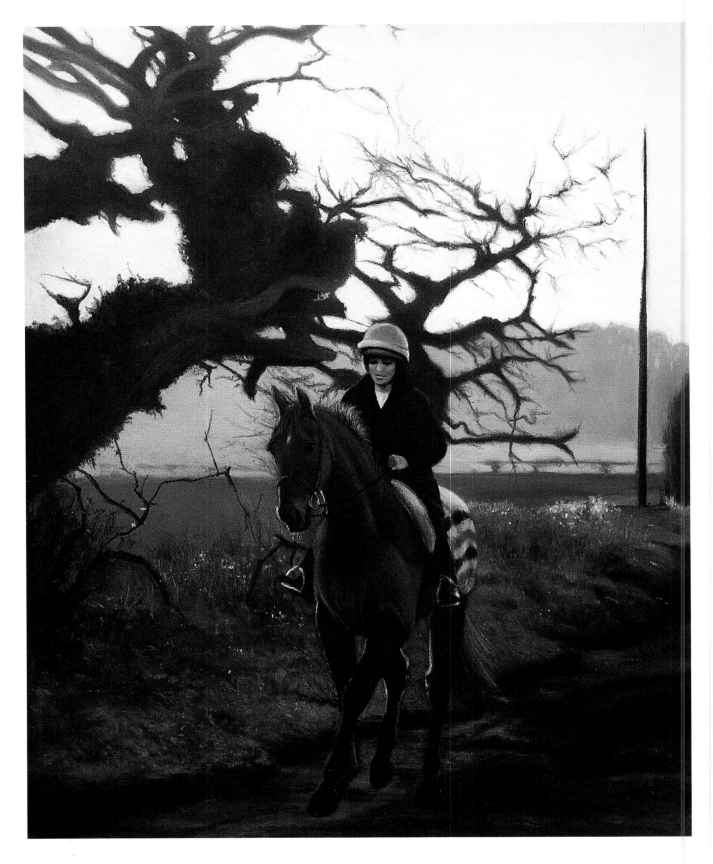

GOING HOME (1991)
57CM X 44CM (22IN X 17IN)

'*This is a picture of myself and my horse Dilly going home after exercise. I cheated quite a bit.*
I painted the landscape first and then added Dilly from studies I'd done of him in the stable yard.
I put myself in later, using a small photo as reference.'

ENCHANTED WORLD

THE ART OF ANNE SUDWORTH

COMMENTARY BY JOHN GRANT

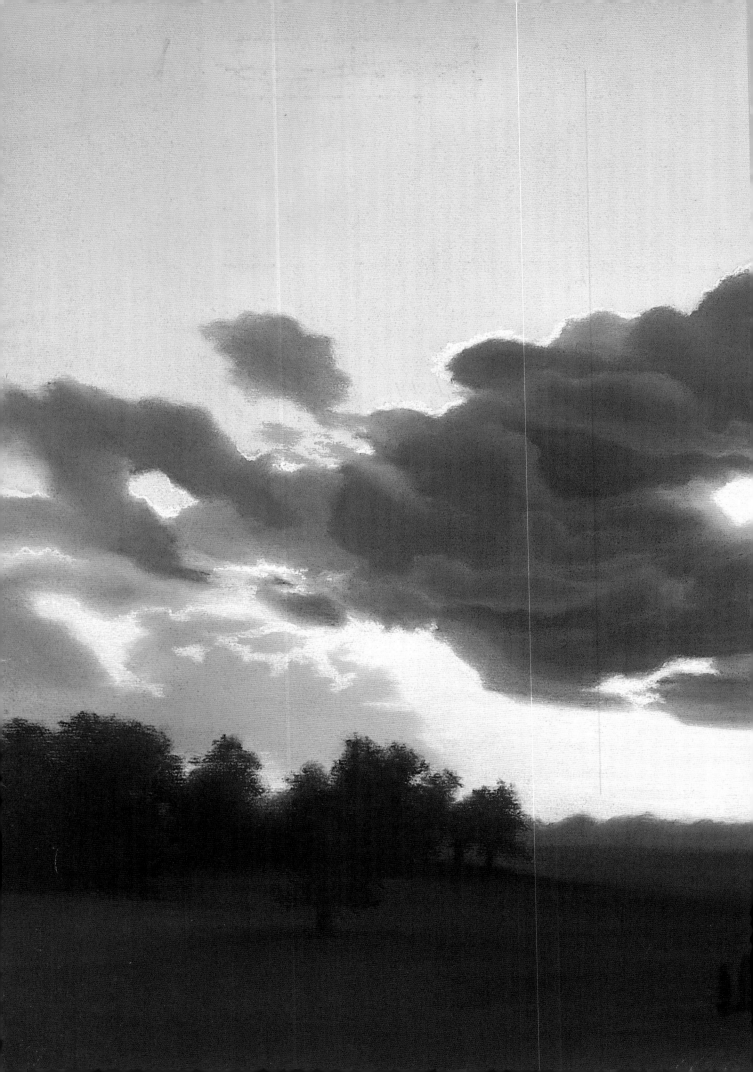

OF FANTASY AND REALITY

ANNE SUDWORTH is one of the most significant painters of fantasy at work today.

That statement requires immediate justification, of course, since you will search in vain to find her name in most of the fantasy-art reference sources. The reason for this apparent oversight is simple enough: such sources are concerned almost exclusively with fantasy (and more usually science fiction) illustrators, even though they may tip their cap to such figures of fantastic art's history as M.C. Escher, Richard Dadd, Salvador Dalí and René Magritte. The task of an illustrator is a specialist one: it is to produce an illustration – a piece of art that is attached to a specific work, designed to promote the work and, most significantly, to look good in print. It is a by-product of modern technology – not to mention modern economics – that almost all of our best and most imaginative fantasy artists are currently working in the field of illustration.[1]

It is, therefore, easy to forget that there are other fantasy artists, artists who work outside this particular field – whose area of operations is not illustration but Fine Art. A number of fantasy illustrators produce Fine Art in addition to their more commercial work – one thinks of, for example, the excellent abstracts and semi-abstracts of Ron Walotsky. Some, such as Bob Eggleton and John Harris, create paintings that can be illustration and Fine Art at the same time; the doyen of such artists was, of course, the late Richard Powers. But more pertinent to the current argument are those who, while their works may on occasion be used as book or CD cover illustrations, essentially do not illustrate: they are Fine Artists, pure and simple. They march to their own drummer, with no need to observe the diktats of commercial illustration.[2] They may, in some instances, go

largely overlooked by genre enthusiasts, but the quirky, quasi-Surrealistic paintings of Judith Clute, the obsessive 3D constructs of H.R. Giger and the painted Amazon parrot feathers of Theresa Mather are as much fantasy art as anything by Frank Frazetta or Michael Whelan.

With others I have argued that the essence of fantasy art seems to be that it is a narrative form.[3] This, it should be noted, is a *description* rather than a *prescription* – we were observing, not ordaining – and it applies as much to Fine Art as to illustration. Perhaps uniquely among the thematic classifications of the creative arts, there is little discontinuity in the expression of fantasy across the spectrum of that genre, whether the conduit be the written word, cinema screen, painted canvas, poem, song or whatever other means the creator uses. All depend to some degree on the notion of *story*, and in the case of the painted fantasy picture this most commonly means that there is a kinetic at work. Although the artist displays what seems to be a simple thing, a single motionless scene, there is nevertheless a sense that it has a *before* and an *after*.[4]

Perhaps its most overt example in this book is *The Arch* (see page 87). This is a straightforward 'view', yet it is full of a sense of motion and the profound expression of story. As the central character in this particular story you are fully aware, as you look at the archway, of the fact that you *have* approached or encountered it somewhere amid strange country, and that shortly, it is inevitable, you *will* go through it to the lands beyond.[5]

There is a further trick the artist of the fantastic can perform, although it is very rarely successful. This is to create an image, whether it be illustration or Fine Art, to which one's only possible response upon looking at it is that it is not so much a fantasy picture as a picture *of fantasy*. One

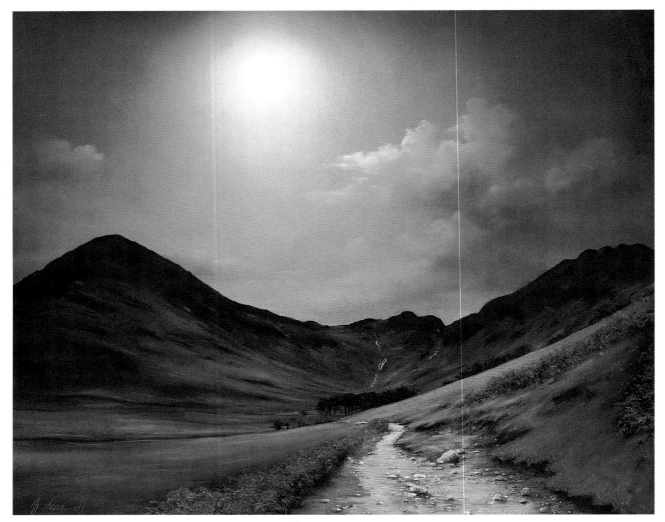

Above and pages 10–11
BUTTERMERE BY MOONLIGHT (1996)
53CM X 66CM (21IN X 26 IN)
FLEETWITH BY MOONLIGHT (1996)
58CM X 85CM (23IN X 33IN)
'These two pictures show different views of a place that is very special to me. I have done endless paintings of Buttermere and its surrounding fells in all their different moods and seasons. But by moonlight Buttermere is particularly magical.'

example is Ron Walotsky's *Fantasies* (1991), created as an interior illustration for *Amazing Stories*; another is Judith Clute's astonishing *Footpads of Darwin #1* (1994). And there are a few – a very few – artists who perform this particular feat not just now and then but virtually all of the time. René Magritte very self-consciously and deliberately did so; who can look at his *Le Château de Pyrénées/Het Kasteel in de Pyreneën* (1959) – showing a castle, and the rock upon which it stands, floating above a choppy sea – without feeling that one is looking directly into fantasy's soul? Like Magritte, but without his self-consciousness, in that the images she paints are superficially mimetic rather than surrealistic, Anne Sudworth creates picture after picture that shows fantasy naked.

There is a further considerable difference between the paintings of Magritte and Sudworth. Magritte does most of the work for you; Sudworth doesn't. Magritte's alternate reality is very ostentatiously fantasticated, so that your own imaginative contribution to the viewing

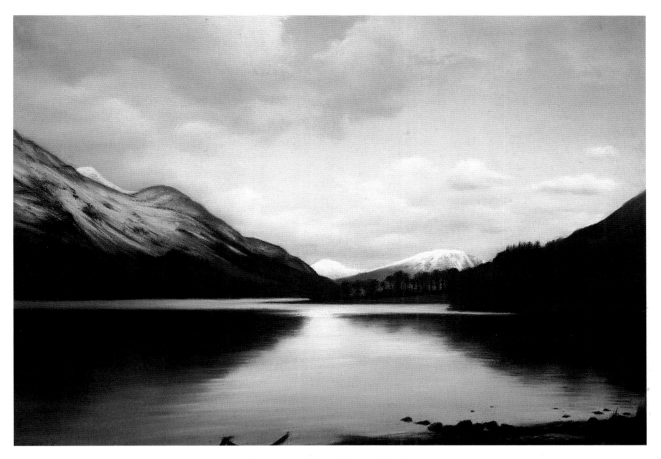

SNOW ON RED PIKE (1990)
47CM X 65CM (19IN X 26IN)
'*Red Pike is part of a range of fells near Buttermere. It's a very rugged place;
somehow it seems much gentler when it's under snow.*'

experience, to the generation of the kinetic fantasy that makes viewing Magritte's paintings so exhilarating, is a comparatively minor part of the equation. Sudworth's landscape of the mind, however, is not nearly so overtly skewed from normality. At a quick glance, many of her paintings can look almost photographic. The viewer's contribution to the fantasy dynamic is drawn from somewhere much deeper, is more profound, is more a product of factors other than the intellectual than in the case of Magritte. To take a single example, even were *The Fairy Wood* (see page 34) not so titled, it would require an exceptional literal-mindedness on the part of the viewer not to be emotionally affected by the feyness – the 'fairyness' – of the painting, not to discern the fairies present in every stroke of the brush, in every gentle cadence of the light.

These are the reasons why I say that, to repeat my words exactly so there can be no confusion, Anne Sudworth is one of the most significant painters of fantasy at work today.

In theory, the details of an artist's biography should be an irrelevance: all that matters when one is confronted by an artwork is the artwork itself. In practice, however, knowledge of the creator's background adds greatly to one's further appreciation and understanding of any piece of art.

Anne Sudworth was born and raised in Lancashire, England, and began to draw almost as soon as she could pick up a pencil. Her mother, Christina, recalls:

From the earliest age, she was able to capture on paper the image of anything she chose. She was never long without a drawing implement in her hand. Any advice or instruction Anne was given was always greeted with a gentle smile, but was ultimately ignored. Even then, Anne knew exactly what she wanted to draw.

Such independence of spirit has continued to this day, which is perhaps one of the ancillary reasons why Sudworth, unlike so many of her

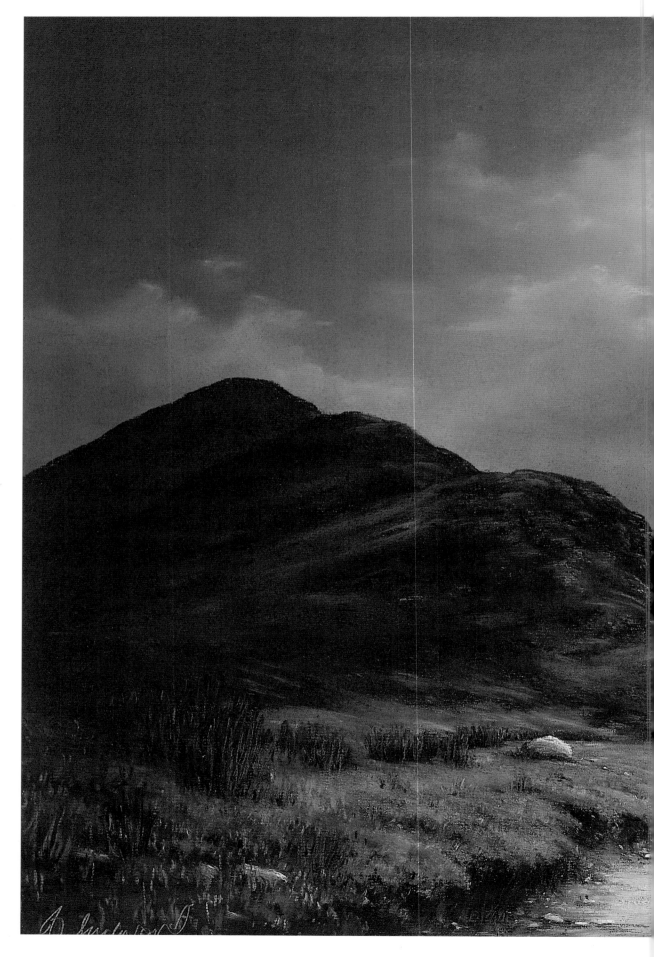

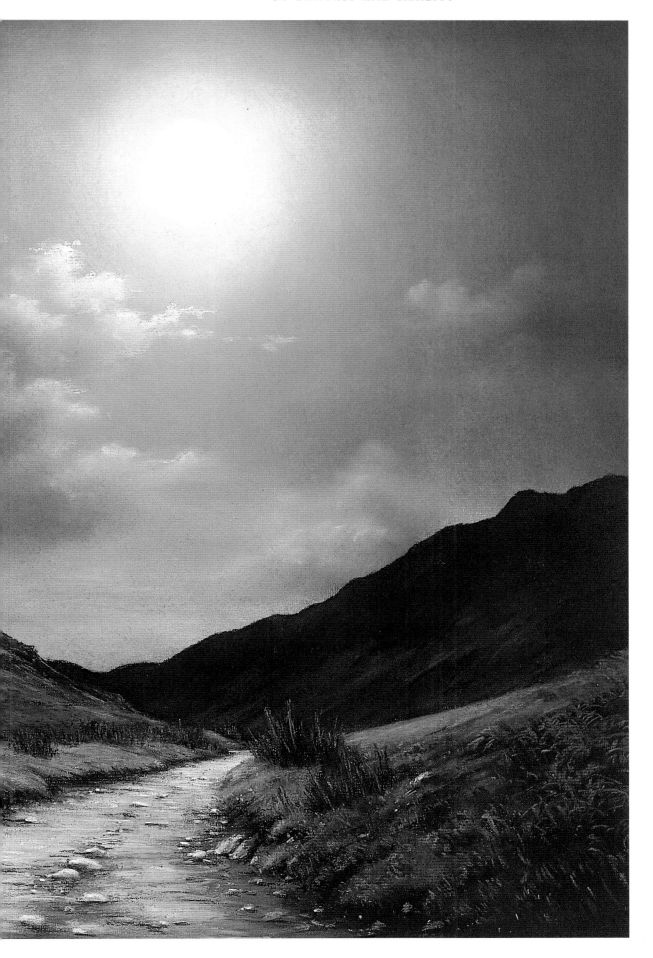

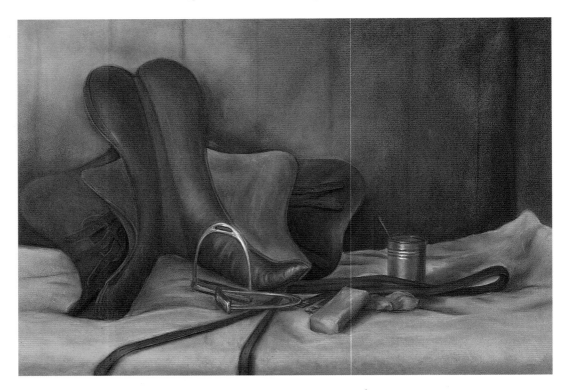

Above:
CLEANING TACK (1989)
63CM X 91CM (25IN X 36IN)
'*This picture was actually done in my tack room at the stables. It's quite large for a Still Life, and was hard to work on in the space I had. It's of my own saddle and stirrups. I think anyone with a horse will be able to identify with this scene.*'

Left:
RACING SILKS (1989)
94CM X 62CM (37IN X 24IN)
'*One of the trainers I used to ride for kindly let me borrow some racing silks for this Still Life. I tried not to arrange them too much, as I wanted it to look as though they had simply been left on the stool.*'

Right:
GOING TO POST (1990)
36CM X 50CM (14IN X 20IN)
'*A horse in action is one of the most beautiful things to watch. It's also one of the hardest things to capture in a painting. I did many studies of horses for this picture, then used reference photos as well.*'

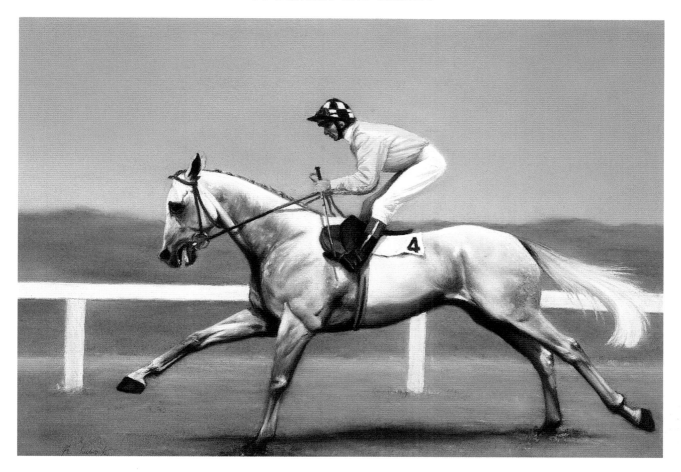

contemporaries, has never really shown any great interest in illustration.

Important childhood influences upon her art included long family holidays spent at two country homes owned by friends. One of these was Pinewood Cottage, nestling into a hillside in Anglesey, Wales, the back garden petered out into a pine wood, where many rare birds and animals could be found – some so unafraid that they would come right up to the cottage. In the surrounding area there were further acres upon acres of unspoiled woodlands to explore, and, of course, there were the Anglesey landscapes. On a nearby island, attainable only by a causeway, was an old church that soon became a favourite haunt of Sudworth's, as did its cemetery, where ancient weathered tombstones bore mysterious and atmospheric testimony to the passage of time. Here was reinforced the young Anne's fascination with architectural ruins of all kinds, from stone circles and monoliths to churches and castles.

The other holiday home possibly had an even more profound effect on her art, an effect that is still evident in many of her fantasy paintings. This was Gatesgarth Farm, set in a very quiet area of the English Lake District.

The Lake District is one of the most beautiful and dramatic parts of the British Isles. Although it is extremely popular with tourists, for some reason this has done little to spoil it – perhaps because a very high proportion of visitors go there for generally eco-conscious activities such as hillwalking, perhaps because the landscape itself convinces all but the obdurate tourist that there is a treasure here which should not be violated. The mountains are not large, but they seem so, with their steep, rocky, snow-specked sides plunging down to the narrow lakes, or 'waters'. Here writers as diverse as William and Dorothy Wordsworth, John Ruskin and Beatrix Potter have found their inspiration, and the roster of artists and photographers who have done likewise is long indeed. Visiting the area, it is easy to see why. Lake District scenes are frequent in Sudworth's work and also colour her invented landscapes.

Another constant influence on Sudworth's art to be initiated during her childhood is her association with and affinity for animals, particularly horses – she has ridden since she was six. She has had her horse, Dilly, since the end of her school days. Dilly, a chestnut thoroughbred who was flat-raced as a two-year-old, for some reason

YORK RACES (1990)
50CM X 66CM (20IN X 26IN)
*'York has a very picturesque racecourse. This is one of my mother's favourite
courses; she owns this picture.'*

seems to bear a grudge against all of the world except his owner; he has done a great deal of damage to property and people. Yet, in her hands, he is almost childlike in his affection. In some form, he has featured in many of her fantasy paintings – such as *The Wizard* (see page 67) and *The Edge of the World* (see page 63). A self-portrait of the artist astride Dilly is *Going Home* (see page 6), set in the lane outside an old farm-house that, for a time, she was hoping to buy.[6]

For years, it had been accepted by her family that Sudworth's future lay in her becoming a professional artist, and so the natural course after school was for her to go to art college – Cheltenham Art College, England, to be specific. It was a decision that she was later bitterly to regret. While at school, she had been lucky enough to have teachers who, recognizing the depth of her extraordinary innate talent, had largely given her a free creative rein. With this as a background, and her own certainty about what she wanted to do in her work, it was predictable that she would have difficulty taking instruction from tutors. Similarly, it was difficult for her tutors – weary, as all art-college tutors are, of wilful students who have inflated ideas of their own abilities and importance – to accommodate the fact that Sudworth was that *rara avis*, a student who actually *did* know what she was doing and where she was going. Much as she tried to follow their advice, she always quickly reverted to her own distinctive style.

For her, the crunch came about over the medium in which she chose to work. Although she used (and occasionally still uses) a variety of other media in her work – including oils and water-colours – she had begun to experiment with pastels just before going to Cheltenham and immediately felt a great affinity for them (indeed, she now uses them almost exclusively: all the pictures in this book are in pastels). It was an enthusiasm unshared by her tutors: pastels, they decreed, were fit only for use in studies, not for finished paintings. All who know Sudworth soon realize that she is quite fearsomely resolute in the pursuit of what she believes to be right, and this attempt to ban her use of pastels was a sticking point.

She decided that, as good as it might be for others, art college was a mistake for her. She had found no great enlightenment there, and probably would have found little in any other art college. In future she would work alone, with her only tutors being her own drawing and painting, her own observations of the natural world.

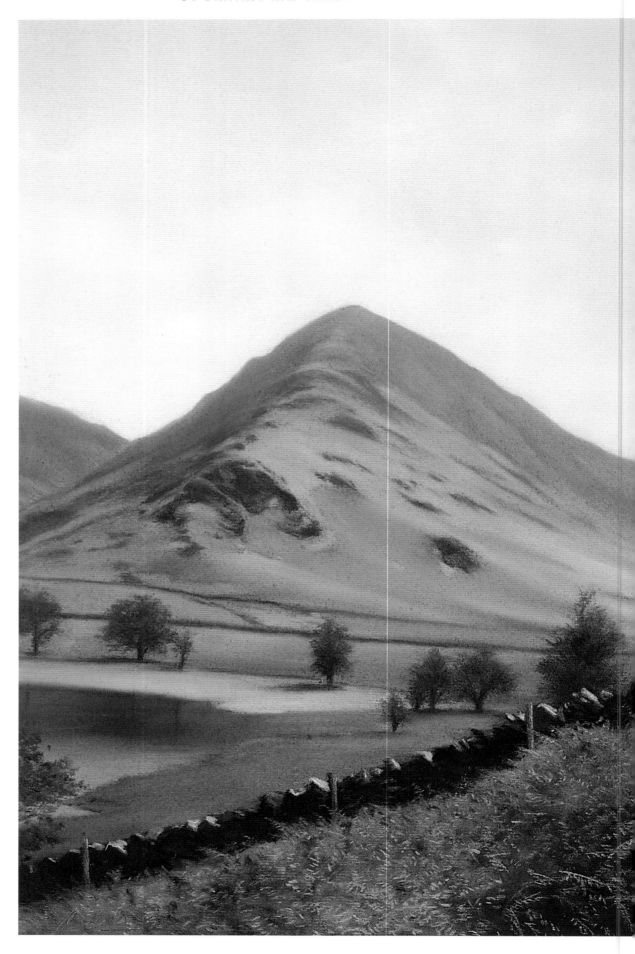

Preceding pages
BUTTERMERE (1991)
50CM X 66CM (20IN X 26IN)
'This is a picture of the fells around Buttermere Lake. It's a place I've used a great deal in other paintings. Here I simply wanted to capture the moment of the day.'

Sudworth returned to Lancashire and went about setting herself up as a professional artist. Many talented artists have done the same, only to be forced by lack of sales into the anonymity of advertising or into becoming 'hobby' painters, working only during the evenings and weekends left free by mundane day jobs. Luckily for her and us, Sudworth's ability and her astonishingly skilful, naturally evolved technique were too considerable for this to happen to her and she soon found patrons.

Her choice of subject matter, too, played a major part in enabling her to establish herself. As a result of her love for horses and riding she began to paint racing scenes. Her facility for capturing the natural grace and movement of the horse ensured that, soon, devotees of the turf were seeking her out. Her other major topic was the wild, untamed landscape of the Lake District, where she continued to spend much of her time. Lake District paintings sell fairly well even when they're bad, so it is not surprising that an artist of Sudworth's ability found an eager market.

Sarah Holmes, the owner of the Grove House Gallery in Keswick, soon became a good friend and an important early influence. For any artist who has just turned professional, the business of exhibiting and making sales thereby can be a minefield, but Holmes's patronage and encouragement helped Sudworth through this tricky phase of her career with the minimum of tears. Holmes gave her invaluable professional advice, and the friendship and business relationship continue to this day: Sudworth very successfully exhibited solo at the Grove House Gallery in the spring of 1999 and again in the spring of 2000.

Sudworth could have become just another jobbing artist, albeit an unusually talented one. She made her living, those first couple of years, through painting a mixture of equestrian and domestic scenes and, on the side, doing some fashion modelling and exercising other people's horses. But at the same time she was exploring in her private work a very different territory – the territory of the imagination.

With two parents passionately interested in English literature – from Chaucer, Shakespeare, Wordsworth and Hardy to modern authors – Sudworth grew up in a family where reading was a natural part of existence. When she was about ten, she came across J.R.R. Tolkien's *The Hobbit* (1937) and enjoyed it; but a much more important event was the discovery, in her early teens, of the same author's *The Lord of the Rings* (1954–5). Once picked up, the book was impossible for her to put down again. This very English fantasy disported itself in a playground whose appurtenances were so many of the things she already felt moved by. She had always loved Celtic mythology and Celtic fairy tales, and certainly anything to do with magic and dragons. High fantasy like *The Lord of the Rings* could, therefore, have been tailor-made for her.

The Lake District landscapes she was using as subjects for her paintings – why, those rugged, craggy, depopulated expanses could be the homes of dragons, fairies, or any manner of fey creatures. It is not surprising that, as she was presenting herself to the public as a landscape artist, she was also painting her 'true work' – pictures of the unseen, or the only partly seen.

One of her primary strengths has always been her ability to manipulate light, which, in her hands, becomes not merely illumination but, in effect, a character in the stories that her fantasy paintings tell. Moonlight can bathe a scene in tranquillity or lend to it a steely-cold spiritual chill, a tincture of the strange; it is no coincidence that the moon plays such a fundamental role in so many of her paintings.[7] Then there is the mysterious 'Earth Light' seemingly emitted by the trees in so many of her paintings. Her mastery of the play of light – often evident also in her non-fantasy paintings, like *Fleetwith Pike* (see page 100) – was another factor in her determination to explore in paint those territories of the mind into which her reading and her own imagination had drawn her.

Many artists have 'true' work which is rarely displayed – it may be what they believe they were put on this earth to create, but it doesn't pay the mortgage. For a while Sudworth assumed she would be following in their footsteps: landscapes, portraits of people and animals, racing scenes and so forth for the world, and fantasy paintings for her private satisfaction. She was lucky enough to have a faithful band of patrons who bought her more conventional paintings; it never occurred to her that they might be interested also in the 'true' ones. However, from the early 1990s, when she began to show her work in various exhibitions around the country, she cautiously introduced a

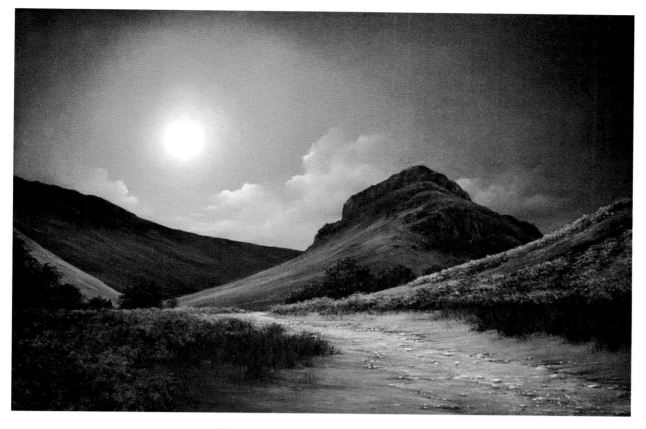

LOOKING FOR THE SIDHE (1996)
49CM X 71CM (19IN X 28IN)
'Some of the Irish fairies were called the Sidhe or Sida. They were thought to live under enchanted hills – in fact,
the word sid (I'm told) means an enchanted mound or dwelling. The enchanted hill here is in the middle distance.
This picture is based on a real place, though I changed the colours considerably.'

few fantasy paintings – and then more, as she discovered quite how enthusiastic the response was. By the time of her first solo exhibition – *Visions and Views* at the St Helens Museum and Art Gallery in 1993 – she was sufficiently confident in her new audience that not just some, but the majority, of the paintings on display were fantasy. Her Earth Light tree pictures were especially popular.

Emboldened, she began to devote more and more time to her fantasy work. As her reputation grew, she stopped having to take on commissions – although she still does the occasional commissioned piece for friends. Her 'true' work became not just the aesthetic and emotional focus of her art, but its commercial focus as well.

Her second solo exhibition came in 1994 with *Other Visions, Other Views* at the Salford Museum and Art Gallery, and by this time she was a well-recognized fantasy painter. Nearly two hundred and fifty people attended the private view, and the show attracted the attentions of the media. By now there was no question over the fact that

she had established herself as a serious gallery artist and as a significant painter of fantasy.

Further solo exhibitions have followed – including *Dreams and Whispers* in 1997, *The Dark Side* in 1998 and *The Enchanted Earth* in 1999. Since 1997, Sudworth has also exhibited occasionally at a number of fantasy and science-fiction conventions throughout the UK. This step has gained her a new audience, both among the public and other artists. It has also given her important opportunities to meet many fantasy illustrators and authors. The talented British fantasy sculptor, Warren Hudson, is more than a friend: he is Sudworth's life-partner.

Both inside and outside the fantasy genre, the Sudworth success story has been quite remarkable. Although she is a comparative newcomer to the scene – and particularly to the fantasy scene – there is a widespread sense among her existing devotees that this, the first book of her art, is long overdue.

For those who are unfortunate enough not to have encountered her work before, let this book serve as an introduction to the magical playground that is Anne Sudworth's vision.

STAY (1997)
67CM X 85CM (26IN X 33IN)

'*Many people have told me they find this picture sinister.
I agree the two figures do not look entirely friendly. I leave it up to the
viewer as to what exactly they are – vampires, shape-shifters, perhaps a
witch and her familiar. I wanted them both to appear strong and perhaps
a little frightening, and tried to capture an atmosphere of anticipation. I
also wanted their expressions to have a hint of aggression yet control, and
to give the impression that, even though the woman faces to the side, at
any moment she could shift her glance and you'd be seen.
My friend Michelle was the model. She has exceptionally strong features.
In the studio, we used a chair lying on its side next to her to represent the
panther; I added him later. It must have been difficult for her to play the
part and give me the expression I wanted when she wasn't actually on a
wild moor but indoors – and asking a chair to "stay"!*'

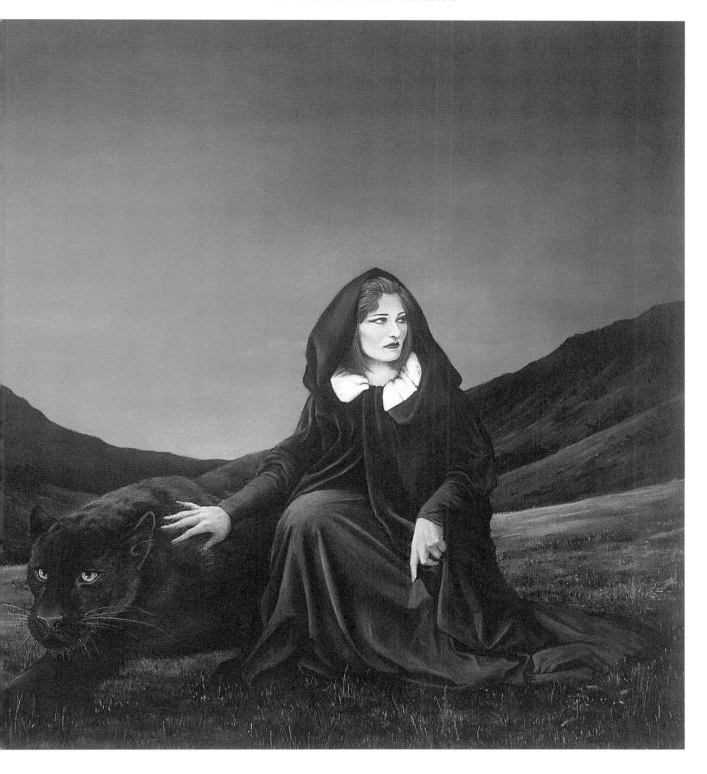

THE FOREST (1993)

140CM X 85CM (55IN X 33IN)

*'I decided from the outset that I wanted this to be a big picture, and in fact it turned out to be my
largest tree painting to date – it's almost five feet high.'*

OF LEAF AND TREE

IT IS HARD TO EXPLAIN quite why trees play such an important part in the human imagination. One hypothesis is that, after we had as a species ceased to be arboreal, but while we were still more at home in forests than in houses, trees represented an essential part of our survival. Forests offered sanctuary and food, of course, but, more importantly, in terms of our ancestors' psyches, trees' upper branches represented vantage points from which potential enemies or other threats could be observed from afar. Numerous psychological studies have indicated how fundamental to us is this notion of a high vantage (to take an extremely mundane example, people who wish to dominate stand while others are seated, and few of us like being stood over in this way), and climbing a tree would have been the most frequent means whereby the ape that walked erect could attain such a perch.

Moving from the anthropological to the mystical, we encounter the widespread idea that trees possess spiritual power, or that they are channels of our planet's own, greater spirit. Whether one believes this or not, it is hard not to feel the force of at least its *subjective* truth as one stands in the shadow of an ancient oak or listens to the rustle of branches in the midst of an otherwise silent forest. Sudworth, with her heightened artistic sensitivity, describes this in terms of the Earth Light that she 'sees' trees exuding:

It's a kind of symbolic, sometimes spiritual, sometimes physical, light which shows the earth's power – particularly in trees. It's the main theme running through my work, and one that I'm continuing to explore – the idea that the earth has a darker, lesser-known side, perhaps one of which our ancestors were more aware.

This is the strange, uncanny light that characterizes so many of her arboreal paintings. It is elemental – it pertains to a world not normally revealed to our conscious senses – and yet it is in no sense threatening or malevolent; rather, it is welcoming, embracing, warm. As we look at it, we have the feeling that we are seeing the tiniest manifestation of a vast power, a power that is greater than the human mind is capable properly of comprehending. To view this Earth Light is to experience the soft brush of the transcendental against one's skin, like a capricious little breeze at the fringe of a great windstorm.

The profound, if subliminal, importance of trees to the human consciousness is most evident in mythologies from all around the world. In the Semitic tradition, there is the Tree of the Knowledge of Good and Evil, the eating of whose

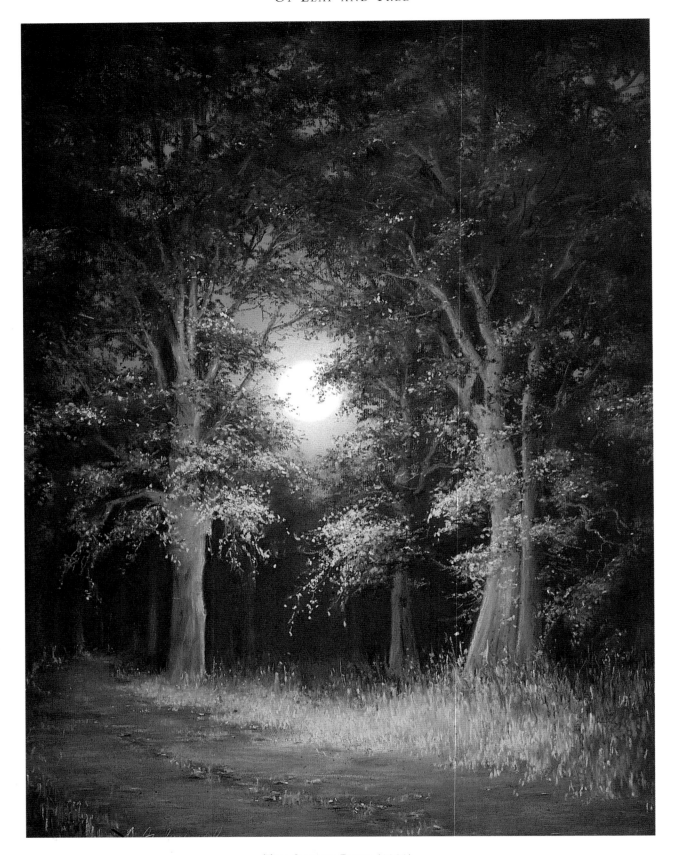

THE SECRET PATH (1993)
47CM X 35CM (19IN X 14IN)

'This is from a series of five pictures called Into the Woods. *Each picture uses very soft blues and greens, and is based around a simple composition. The trees here are silver birches, trees sometimes thought to represent new beginnings.'*

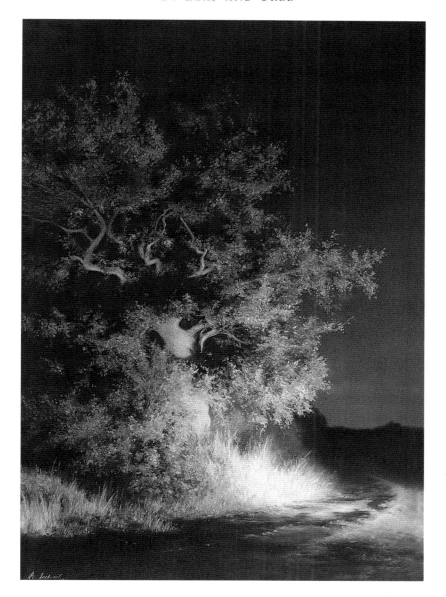

TREE SPIRIT (1996)
72CM X 49CM (28IN X 19IN)
*'This painting shows an oak tree in autumn colours.
Its light flows out of it, across the path and into the land.
But, although the tree might appear to be dying, it is merely
preparing to sleep through the winter. Its spirit will
return again in the spring.'*

fruit determined the course of human history ever thereafter. The ancient Greeks conceived that individual trees and groups of trees – originally only oaks, but later trees of any variety – were inseparably associated with dryads, or wood-nymphs; the existence of a dryad associated with a particular tree was defined by the tree itself, the dryad perishing when the tree did. To the Norse peoples, the world itself was, in one of its aspects, the great tree Yggdrasil, whose three roots sprang up beside three fountains in, respectively, Asgard (the realm of the gods), Niflheim (the underworld, the realm of the dead) and Jotunheim (the realm of the frost giants). At the Niflheim root gnawed the serpent Nidhögg, while the gods dispensed justice from their assembly place in Yggdrasil's branches. Odin himself hung in torment from the tree for a period of nine days, acquiring mystical knowledge thereby.

Outside Western Europe, similar ideas are to be found in the lores of central Asia and of Siberia and other parts of northern Asia. And it is entirely understandable – if for reasons that differ from one terrain to the other – that trees should have a pivotal function in the mythologies of peoples from the plains of Africa to the jungles of South America. One Native American myth tells that the two bright stars of the Big Dipper were

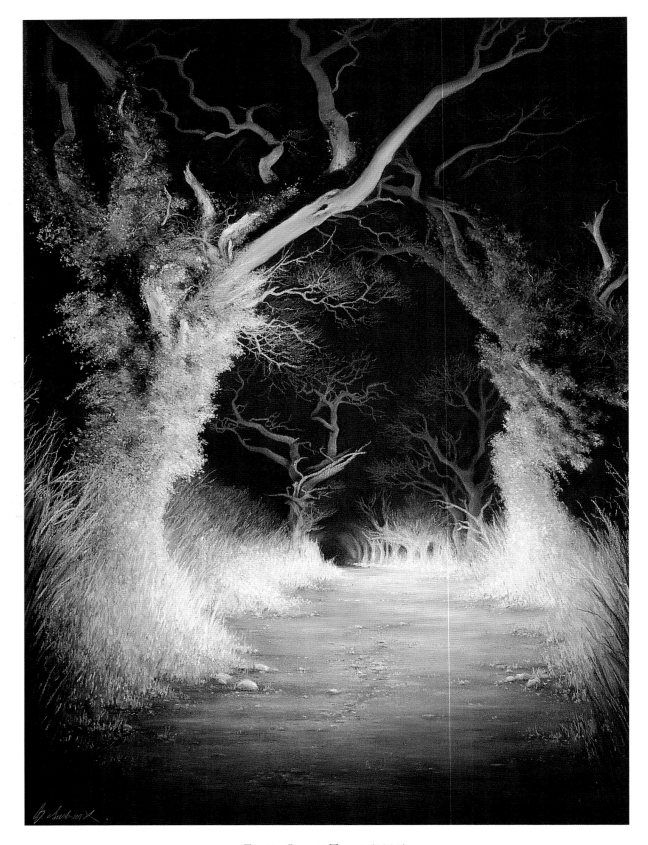

EARTH LIGHT TREES (1995)
87CM X 64CM (34IN X 25IN)

'*Originally I intended the two trees in the foreground to be level with one another, but ultimately I decided to paint the second tree further back than the first. Despite the slight distance between them, they still bend towards each other, so that their branches meet overhead to form an arch. I didn't want the light to come from the two main trees alone; I wanted it to continue further and further into the picture until the arch became almost a tunnel.*'

formed when two girl-children running from a savage bear (their transformed brother) were taken up by a friendly tree into its uppermost branches; the tree then bore them further aloft, where they became the two stars. In the more recent mythologies of the European colonists in North America we discover such legends as those of Johnny Appleseed, who reclaims the wastelands by planting trees wherever he goes, and Paul Bunyan, who, with his staunch ally Babe the Blue Ox, fells the trees of the great forests, thus in a contrasting way serving to tame the wilderness.

The Western literary tradition that gave rise to the modern genre called fantasy was, of course, born from myths and fairy tales, and fantasy – whether written, filmed or painted – can be regarded as the deliberate creation of new mythologies. It is unsurprising, from this viewpoint, that trees should figure so heavily in it, from the Alder-Maid, the treacherous tree spirit of George Macdonald's *Phantastes* (1858),[8] through the tree city in Jules Verne's *The Village in the Treetops* (1901), the giant banyan of Brian Aldiss's *Hothouse* (1962, also titled *The Long Afternoon of Earth*) that covers all the world and among whose branches humans are scuttling tree creatures, and the Ents of Tolkien's *The Lord of the Rings* (1954–5) to the kindly advisor Grandmother Willow, a figure loosely drawn from Native American mythology, in the Disney animated movie *Pocahontas* (1995). In the visual-arts equivalent of written fantasy, the significance is evident everywhere, from the tree-arms of the hollowed man in the right wing of Hieronymus Bosch's *Garden of Earthly Delights* (1505–10) to the looming, menacing boles in Sir Joseph Noel Paton's *The Fairy Raid* (1867) to the arboreal setting of Richard Dadd's pastoral *The Fairy Feller's Master-Stroke* (1855–64).

Thus Sudworth's fantastication of trees might be viewed as following in and developing a rich tradition. Yet at the same time it is something distinctly hers, something completely fresh. Yes, every painter will at some stage or another during her or his career become absorbed with the grotesque and fantastic shapes that trees can adopt – at any amateur art show, one is bound to come across a couple of examples of branches filigreed against moonlight – but in Sudworth's paintings, the fantastication has comparatively little to do with the shapes of the trees. Instead, her fantasy in very large part derives from the light.

This is not to say that the trees' shapes aren't important – far from it. Sometimes the scenes are entirely imaginary, but often they're taken from life – a particular *arbre trouvé* not so much presenting itself as a suitable subject for a fantasy picture as being, in and of itself, a spiritually significant tree that Sudworth paints *as she sees it*.

Or as we ourselves see it. *The Forest* (see page 22), for example, is to some eyes – my own included – almost a strictly naturalistic scene. My childhood was spent in the north of Scotland, and for a couple of years my family lived in the tiny village of Pitmedden, some twenty miles out of Aberdeen. We had an ancient Daimler that ran like a dream but gobbled petrol at a terrifying rate. Sometimes on a winter's night, long after my usual childhood bedtime, we would drive home along the winding country roads through the woodlands, and through sleepy eyes I would see, in the headlights, the scene that Sudworth has painted as *The Forest*. Others will, obviously, have seen this treescape elsewhere, and in quite different circumstances; yet it is very precisely these childhood memories that make it so evocative for *me*.

Indeed, I've more than once heard people say, on first being confronted by a Sudworth tree painting, that the source of that uniquely glowing, almost phosphorescent, light must be car headlights. It is only on closer examination, feeling that

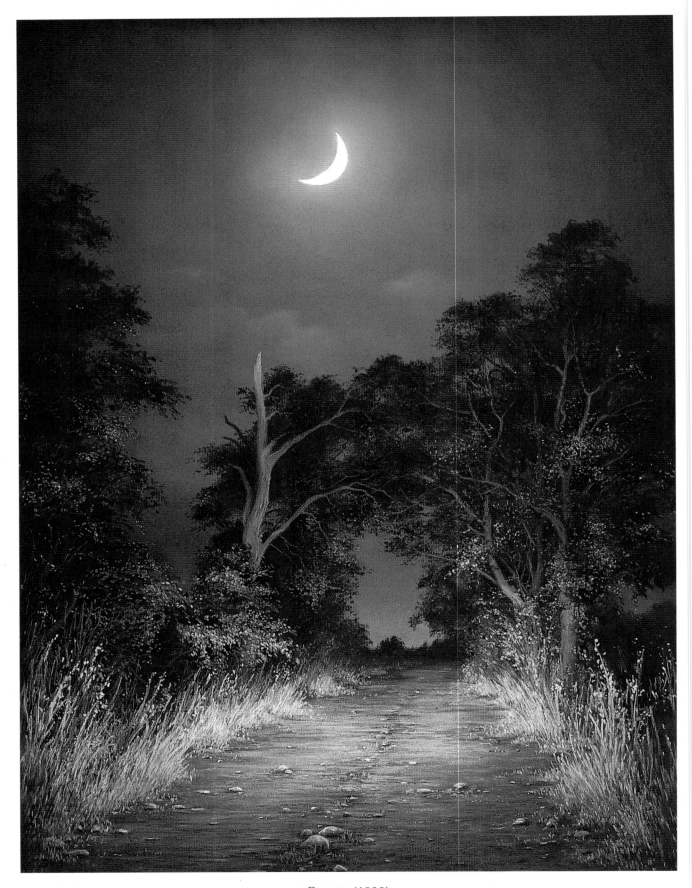

GHOST (1998)

73CM X 55CM (29IN X 22IN)

'Trees are always wonderful. Even a dead tree – a ghost – can be fascinating and full of character.'

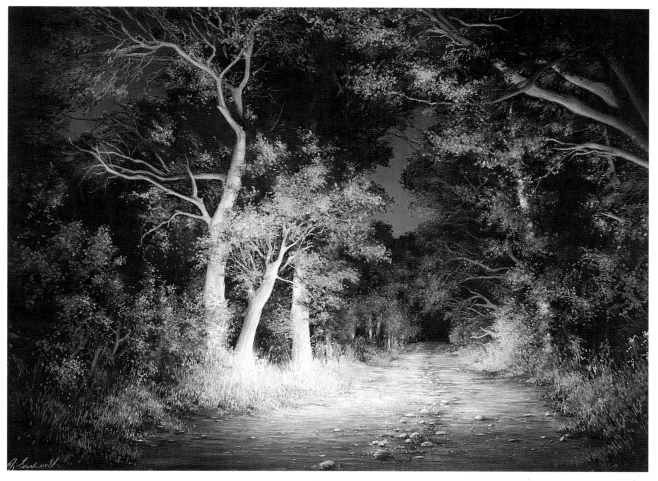

THE EDGE OF THE FOREST (1998)
59CM X 76CM (23IN X 30IN)

'*I wanted this forest to have a very fairy tale or dreamlike quality while at the same time remaining real and believable.
I made the canopy of leaves very dense so that the sky is hardly visible and the only light is that which comes from the trees
themselves. I tried to create the feeling of being indoors rather than outside. Sometimes ancient forests can feel like that –
some people even find them claustrophobic.
I decided that, even though the picture was about many trees, there should be certain trees that stood out.
With this in mind I made the three pale trees in the foreground almost like a group of people – I called them the
Three Sisters, and they might not be trees at all…*'

even with this explanation there is still something deliciously *wrong* about the illumination, that they discover the light is not external but integral to the trees themselves – which is exactly the way I *saw* it too, sitting there bundled up in the back of the old black Daimler.

Of this picture, Sudworth says:

The word 'forest' itself refers to the biggest, thickest mass of trees. I wanted to feel as if I were looking into a deep and dark forest from the safety of a small path. The tree in the foreground is a beech. The light comes out of the base of the tree's trunk, illuminating the grasses, the path and the autumn leaves that still cling to the lower branches – beech trees always seem to hold

on to a few of their autumn leaves even after the winter and into spring.

Those autumn colours – the muted russety orange-reds of not just the leaves but also the murky, mysterious depths of the forest air – add an extra level of strangeness to the picture. Moonlight is too weak for the colour-sensitive cells of our retina to kick in, so that in moonlight we see everything in black and white and divers shades of grey. Of course, the beam of headlights would bring out the russet of the foreground leaves, but not those forest depths – which would be that spectral, silver-glistening black which is peculiar to the night-time forests of winter. No, the Earth Light from the trees is both warmer and

29

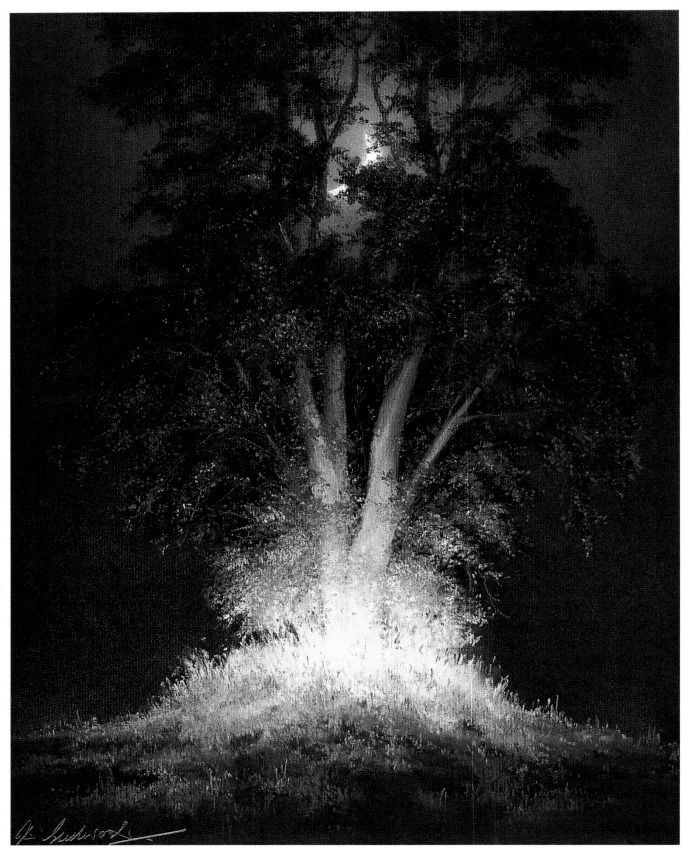

THE MAGIC TREE (1993)
41CM X 31CM (16IN X 12IN)
'*I wanted the branches to stretch up like fingers as if the golden light had released a hand
which reached up for the moon.*'

spectre in this picture, perhaps even a Grey Lady, or a knight in armour with his head under his arm…

It is in *Earth Light Trees* (see page 26) that Sudworth makes the most blatant statement of her Earth Light concept. It's not only the title: here the glow from the path and the bases of the tree trunks is *bright*, as if it were illuminating the stage where some revelrous elemental performance were about to be enacted. The theatrical feeling of the picture is enhanced by the reflectively gleaming branch that reaches towards the upper right; any moment now, the stage curtains that hang from it will open to reveal not a forest path but *something else*. This sense of anticipation is strong throughout the picture, belying its seeming stillness, and yet at the same time we know that the impish show will not commence until we are safely gone: it is not for our eyes, and nor is its wild music for our ears. We could walk straight ahead along that path in front of us if we wanted to – no one would step out of the gloom on either side to stop us – but to do so would be to commit a minor act of desecration, for this ground is special and not *ours*.

By contrast with this vibrancy, the ambience of *The Edge of the Forest* (see page 29) is a cold remoteness. One has the sense that, while the unseen denizens of the woodland in *Earth Light Trees* are, for all their difference in kind from us mortals, potentially amicable – we would be welcome to join them in revel, but not here, not now – those who dwell to either side of the path in this painting are so different from us that communication between us would be possible only by their special dispensation, which is rarely granted through the long millennia of their existence. These are the austere, casually cruel fairies into whose land Thomas the Rhymer strayed, to his peril. There is the chill of outer space, of the unfathomable, about this picture. In large part, of course, this effect is a product of the colour values Sudworth has deployed: the starkly white light from the tree trunks and, bearing in mind the dark of the night sky, the incongruously light

more powerful, more organic and alive, than any passing artificial beam.

The illumination in *Ghost* (see page 28) is even more curious, with the moonlight tingeing the night sky with the kind of louring daytime blue that might precede a thunderstorm and the white Earth Light from the bases of the two lines of trees dwindling into the soft purples of the distance. It is as if the two glows, moonlight and Earth Light, were reaching towards each other like lovers. But there is even more to it than that, as we look at the curiously youthful light on the vertical trunk of the dead tree just to the left of centre – the ghost of the title, although that easy statement simplifies a little. Sudworth says:

> *The ghost of this picture is the spirit of the dead tree on the left-hand side of the path. I wanted to show it standing proud; even though its natural life cycle of the seasons has ceased, its ghost continues to be part of the copse. The waxing crescent moon symbolizes the birth of a new cycle: life will go on. Although the light from the moon just catches the top of the dead tree, it is not the moonlight that illuminates the scene; it is the Earth Light from all the trees along the lane, the dead tree included.*

Needless to say, it is always entertaining to watch the literal-minded searching for some human

Overleaf:
THE ENCHANTED TREE (1997)
58CM X 76CM (23IN X 30IN)
'*I loved this picture before I even started it, if that makes sense. This was partly because I could already see it in my head exactly as I wanted it to be, but also because, of all the trees I love to paint, oaks are my favourite.*'

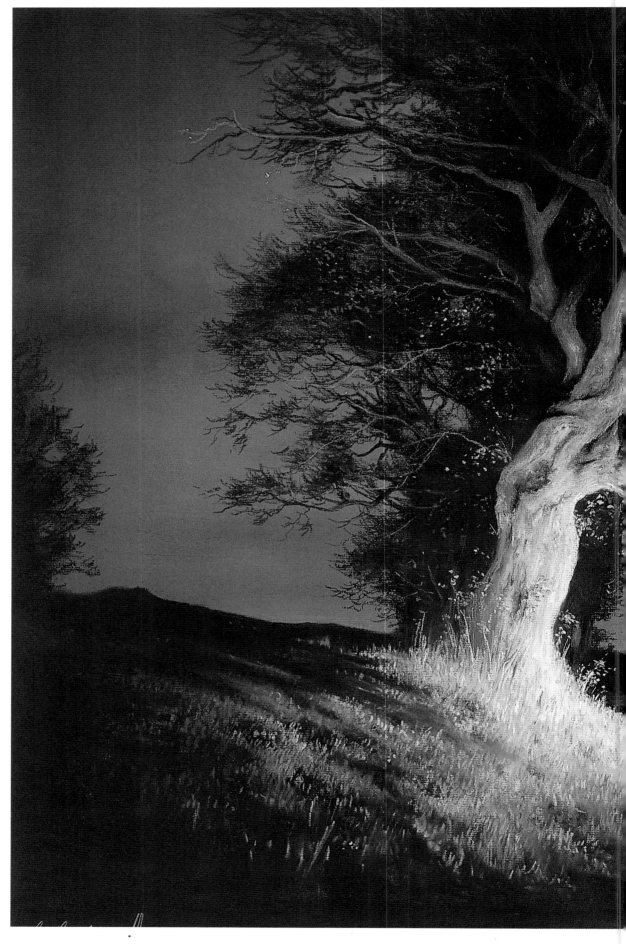

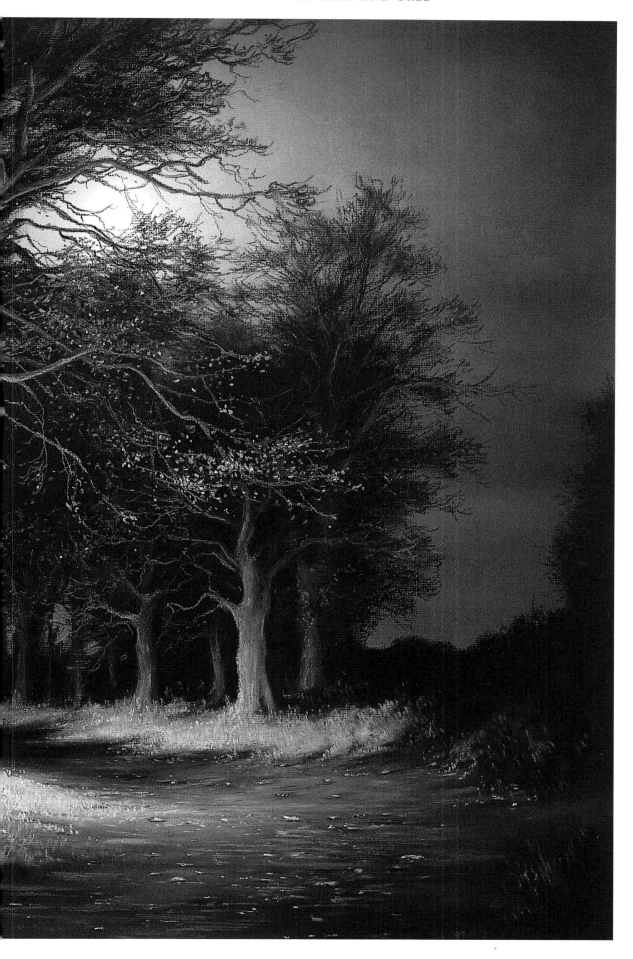

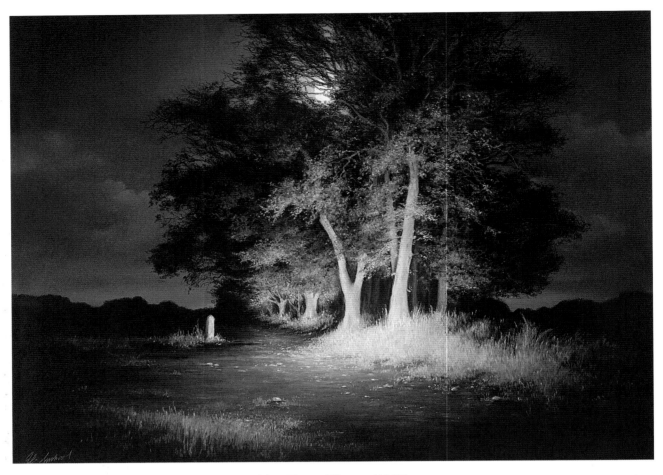

THE FAIRY WOOD (1997)
53CM X 73CM (21IN X 29IN)

'I envisaged the completed painting in my mind, and took a long time painting the trees because I wanted them to be particularly special. I put the little post on the left-hand side of the path to signify a magical boundary, and also to define the edge of the path itself. It's the only man-made object in the picture, and, although it's in the light, it's outside the wood.'

green of the bright leaves. Yet again she has painted the experience of detecting the fringes of the unencompassable, but here the fantasy is disturbingly alien.

Easier to accept – closer to home, as it were – is the scene of *The Magic Tree* (see page 30). The crescent moon, as so often in Sudworth's paintings, is a mute observer. The light blazing upwards from the roots of the solitary tree is almost overwhelming, almost violent in its

Facing page:
THE RED TREE (1995)
73CM X 50CM (29IN X 20IN)

'I didn't want the Red Tree to look like an ordinary, normal tree. To emphasize this there is a more natural-looking tree in the background, further down the path. This isn't as detailed as some of my other tree paintings, but I've always felt it is a very strong picture – some people have even found it disturbing.'

intensity; the passionate physical violence of volcanism is subliminally evoked by the limned slopes of the knoll upon which the tree stands.

The artist has a great deal to say about this tree:

The tree in this picture is a hazel, which according to tradition is a truly magical tree associated with wisdom, divination and knowledge. The hazel is only a small tree but was one of the first to populate the British Isles after the end of the last Ice Age. Perhaps that's why there is such a history of magic and folklore surrounding it. In my picture it's more like a pattern than a tree. It's quite symmetrical, almost too symmetrical to be a natural tree.

This artificiality of composition lends an additional frisson of the strange to the picture. The central figure of *The Enchanted Tree* (see

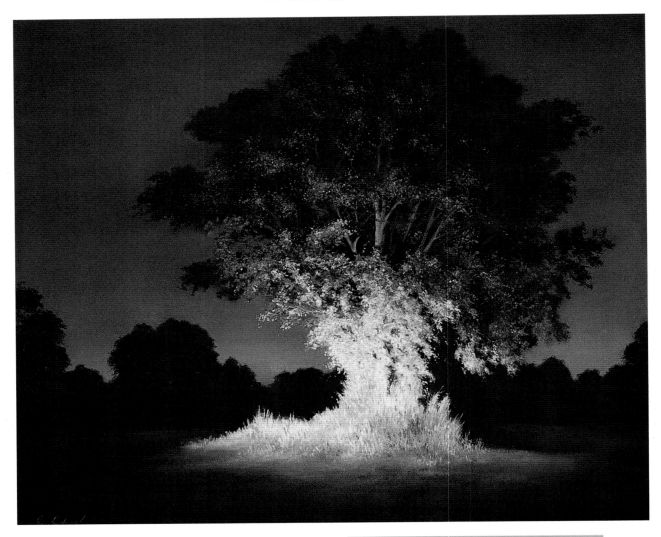

THRICE ROUND THE TREE (1996)
65CM X 78CM (26IN X 31IN)

*'My picture shows a large tree, its base surrounded by a pool of golden light.
I didn't want anything to detract from this image, which is why there is no moon or path in the scene – just a tree.'*

page 32), on the other hand, is completely naturalistic. Indeed, there is something archetypal about this grand oak; even on first encountering the painting one has the sense of looking at the portrait of an old friend. This is one of the most accessible, and consequently one of the most popular, of all Sudworth's tree paintings.

The moon is full and bright; this, coupled with its angle in the sky, gives rise to an intriguing *trompe l'oeil* effect. At first glance, one assumes the ancient oak is lit by the glow of the moon, but then one's mind begins to argue with this glib supposition – the light is, for one thing, the wrong colour; for another, there are pools of light beneath the more distant trees in places where

there should be shade. Only then, reinterpreting, does one see that the source of the light is not the moon but the ground at the foot of the trees.

There is something beautifully loving about the execution of this picture, as if every stroke had been carefully and tenderly applied in an act of adoration. To me, the tree itself is very

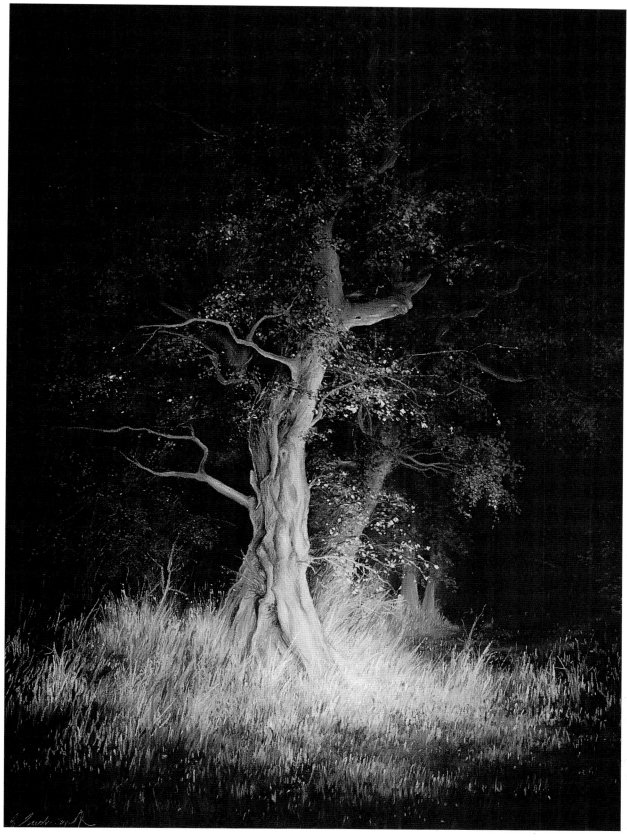

INIFRI DUIR (1999)
69CM X 50CM (27IN X 20IN)

'I wanted the light from the oak to be very vibrant and golden, and to emphasize this I kept almost all of the background in darkness. Without wanting to make the tree look human, I painted it bending over, with its branches like outstretched limbs – almost as if it were indeed able to move.'

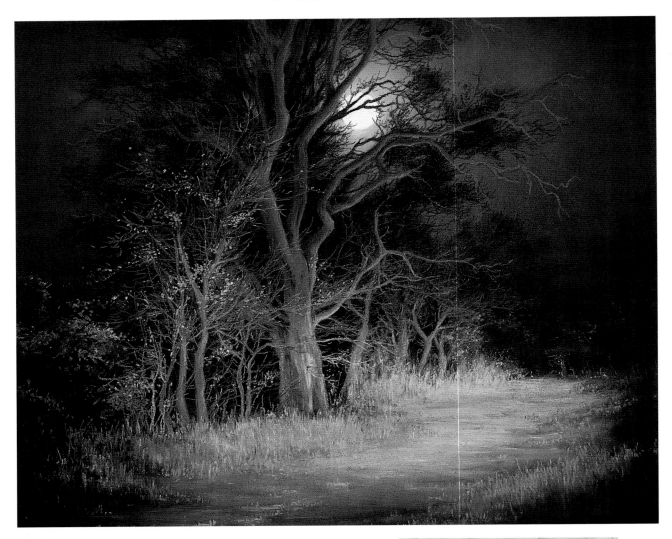

Above:
TEPITH IMBRA (1995)
49CM X 60CM (19IN X 24IN)
'I used hawthorn, elder and other shrubs to create a small
group of trees against a full moon.'

Left:
WHISPERING BEECHES (1994)
61CM X 46CM (24IN X 18IN)
'Another picture from my Into the Woods series.
Here the trees are beeches. The main tree in the picture leans
over to meet another, which is only partly seen. Beech trees
were often associated with secret or old knowledge.'

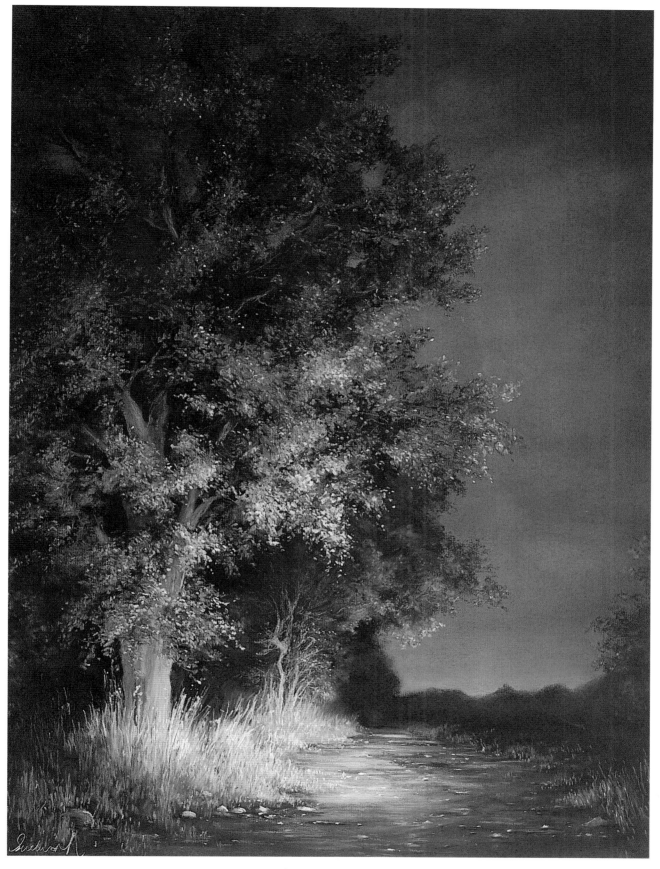

AUTUMN (1997)

66CM X 50CM (26IN X 20IN)

'To me this picture is simply autumn, as the title says. Beautiful tall trees lining a country lane, with all those
wonderful colours – the reds, golds and oranges – and just a hint of Earth Light seeping from the trunks.'

feminine, and very maternal; it has the kind of timelessness that, as children, we associate with our parents – who have their quirks and irritating failings on occasion, but are, essentially, the solid, permanent structures to which in our young, dependent days we cling. Sudworth touches on something akin to my parental analogue in her own thoughts on the subject:

> *The tree in this picture, though imaginary, is most definitely an old oak tree. Although it's not particularly large or impressive in a physical sense, its shape is very strong, and dominates the whole of the picture. The light flowing from it slightly touches the tree on the other side of the path. The bowed branches and the light form an oval in the centre of the picture.*
>
> *Circular and oval patterns frequently appear in my work. I feel they help to draw the viewer in, and I like the idea of being invited into a picture.*

Just like a mother or father, then, even if the tree is 'not particularly large or impressive in a physical sense' to the child, it 'dominates the whole of the picture'; the child's perceptions of all the rest of the world – other adults, the trees 'on the other side of the path' – are seen in the scatter of radiance from the parent figure. To take the analogy further, the oak in *The Enchanted Tree* is perhaps an aspect of the Goddess, the Earth Mother, Gaia.

Visually similar but with entirely different emotional affect is *The Fairy Wood* (see page 34). There is something very haunted about this scene, perhaps because of the shine of the Earth Light on and from the trunks of the more remote trees. Again the full moon peeking through the upper branches gives birth to a *trompe l'oeil* effect, but this is not nearly so marked as in *The Enchanted Tree*. The colour values are chilly, as in *The Edge of the Forest* (see page 29), although the cold is ameliorated by the hints of warm colours in the background sky at the horizon. The coldness of the fairy light touches the only man-made object in the scene – the little post on the other side of the path – and transforms it, too, into something magical, which is, despite its human craftsmanship, otherworldly.

This springtime scene might be wintry cold in its emotional impact, but it does not have the aloofness or austerity of *The Edge of the Forest*. Sudworth has stated as much when describing her own feelings towards the painting:

OF LEAVES AND STONES (1997)
45CM X 64CM (18IN X 25IN)
'*Though the moon appears quite strong, it is the light from the trees that illuminates the path and picks out the
small stones and pebbles.*'

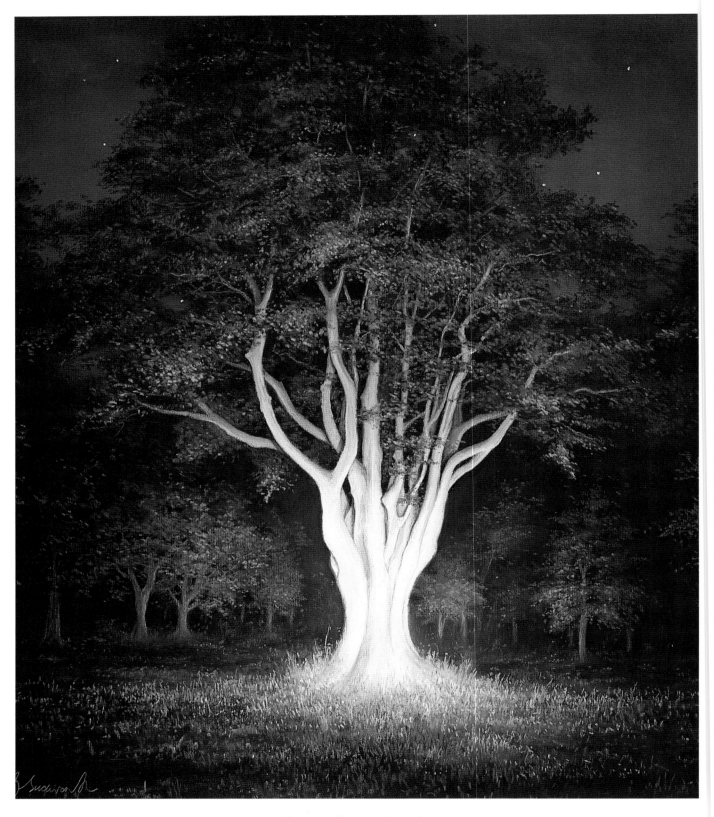

GOWRIM IDHREE (1999)
63CM X 56CM (25IN X 22IN)
'*Gowrim Idhree is the name of a spirit connected to the yew tree and, like the tree,
is said to represent death and rebirth, new life after death.*'

This is a wood that definitely belongs to fairies. But, although it has a supernatural quality, it is benevolent. It's not a dangerous or threatening place for those who approach it with good intentions.

It is maybe no coincidence, in this context, that there's also a slight redolence of the sea – especially in the way the light seems to wash up against the tangled vegetation at the edges of the copse, like small waves breaking against the shore of a tiny island. Just as are the inhabitants of a fairy wood, the sea is powerful and can kill those who seek to defy it – can swat them like insects – yet is 'not a dangerous or threatening place for those who approach it with good intentions'.

The Fairy Wood is yet another magnificent painting, and it is wholly understandable that it should be among the most generally popular of Sudworth's works.

Some of Sudworth's tree paintings have much more specific sources. Among these are *The Red Tree, Thrice Round the Tree, Inifri Duir, Gowrim Idhree* and *Tepith Imbra.*

The Red Tree (see page 35) is a splendidly powerful piece of work – almost erotic in the depth of its passion. Sudworth tells of its genesis:

Some years ago, an elderly lady told me the story of the Red Tree. She said that the tree would react if threatened or attacked. It would bleed, and its blood would turn the sky red, leaving the tree bleached white, although it would not die. My picture was partly inspired by this story. Surprisingly, nobody ever asks me why the tree is called the Red Tree, because it isn't red in the picture.

The tree itself may not be red, but there's plenty of red in the painting. Probably the reason no one ever queries the title is that the angry wildness of the emotions the tree seems to project 'read' as red: blood-red anger, blood-red anguish. There is certainly hostility in the tree, but it is a victim's hostility: it is *reacting* to aggression with a terrifying supernatural strength.

Dangerous and/or hostile trees are comparatively rare items in fantasy. (Dangerous forests are another matter – think of the lashing branches in Disney's *Snow White and the Seven Dwarfs* [1937].) Malevolent trees assail Dorothy and her cronies in the movie *The Wizard of Oz* (1939), and Mytyl and Tyltyl have their difficulties with nasty trees in the movie *The Blue Bird* (1940), but, generally speaking, the trees of fantasy do no worse than allow evil to happen through their lethargy, as per Tolkien's Ents. The killer plants in John Wyndham's *The Day of the Triffids* (1951) and the various screen versions, notably the 1963 movie, are portrayed as being small-tree-sized, but they are not in fact trees. So *The Red Tree* is doubly strange in that we are not accustomed to seeing trees in anything other than a benevolent (even kindly) or passive role. But Sudworth's trees, we must remind ourselves, possess magic; and magic, like the kingdom from which it emanates, has always had its capriciously malicious side.

Thrice Round the Tree (see page 36) similarly derives from folklore – this time from an old rhyme that Sudworth discovered:

Thrice round the tree
I cast for thee
A pool of golden light
Shall be.

She amplifies:

In olden times people would use such rhymes and charms to try to make visible the Earth Light of a particularly special place or tree. The Earth Light was said to give great strength and energy as well as promote a more harmonious relationship between man and nature.

The paintings *Inifri Duir* (see page 37), *Gowrim Idhree* (see opposite) and *Tepith Imbra* (see page 38) all take their titles from the names of tree spirits.

Inifri Duir is said to be an extremely powerful, magical spirit, which guards and protects an oak tree and the land around it. It is said that the word 'door' comes from *duir*, an ancient name for the oak; this is yet another link to the idea of protectiveness, a characteristic of our attitude towards the oak. The crenulations along the length of this particular oak's trunk are like the bulging sinews and veins of an old but still strong man's arms.

Of *Gowrim Idhree*, Sudworth says:

Though this picture is not a faithful rendition of a particular tree, it is based on the yew tree. Sometimes called the Death Tree, the yew symbolizes many things and appears in a great

number of legends and stories. It has always fascinated me, with its wonderful shape and its incredible longevity – some yews are thought to live for thousands of years.

As the yew is a very magical tree, I felt the light from the tree should dominate the scene. I wanted the tree to glow with a radiance, and so the trunk and branches are almost white. Any moonlight in the picture would have detracted from the tree's light, so instead I put white stars in the sky around the top of the tree to suggest the heavens, and blue flowers around its base to suggest the earth.

The spirit Tepith Imbra is not specific like Inifri Duir or Gowrim Idhree; instead it can be associated with any type of tree – although it is believed to prefer smaller, prettier trees rather than the bigger, sturdier kinds:

With this in mind, I tried to create a much softer woodland, almost wistful in mood, yet without making it too pretty. I used hawthorn, elder and other shrubs to create a small group of trees against a full moon. The elder and the hawthorn are said to be very special trees – though small, they are full of magic and energy.

The Earth Light is treated with a glorious softness in this painting. Few Sudworth paintings can be regarded as tranquil – as noted, there is always a sense of the dynamic lurking just beneath the skin – but this is one of them. Another is *Autumn* (see page 39), whose mellowness creates a sense of great and comfortable security.

Pictures like *Of Leaves and Stones* (see page 41) and *Whispering Beeches* (see page 38) are almost tranquil as well, but there is something subtly disturbing about the former in particular – perhaps because of the way that the moon seems to be trying to hide, perhaps because of the uncannily daytime colours of this moonlit scene. And yet the sombre colours of *Whispering Beeches* create their own atmosphere of the unknown; there is also a curious perspective trick in this painting, making one constantly uncertain about the precise position of one's viewpoint. In both

paintings, the detailed treatment of the pebbles on the path adds an extra sense of motion, as our eye is continually drawn away from the trees, the main subject of the painting.

Finally, in this tour through the magic forest of Sudworth's imagination, we come to *The Brow of the Bethansheed* (see opposite). A tall and imposing painting, this takes the breath away. It seems to offer a summation and an apotheosis of everything there is to be found in the rest of Sudworth's tree paintings. All the elements that we have come to expect are here – the observing moon and the blue-silver luminescence of the sky, the preternatural, silent pulse of the glowing Earth Light, the seemingly motile branches caught in an instant's stillness, the phallic strength of the great tree's bole, and the lure of the deserted path as it seeks to draw the viewer into the painting...and into the forest. The dangling streamers of leaves could almost be mosses or vines. The shape that the arching branches frame is reminiscent of the simplified form of a bat with its wings spread, or of a flattened heart, or of one of the vertebrae of the neck – encircling the spinal cord, the seat of our most primitive sub-thought processes. Beyond the single, simple, white-limned line that denotes the crest of the hill, there is...who knows? Nothingness? The realm of the fairies? The dangers of the dark? Something *other*?

The Brow of the Bethansheed is a painting with many layers of conceptual complexity, one that asks many more questions than it answers. These are the characteristics of the very best of written fantasy: to challenge, disconcert, subvert, perhaps to frighten and certainly to force the reader to ask questions of both the text and the world. Those same characteristics should be expected of – but are only rarely to be found in – fantasy art. According to these criteria, as well as to any others one can readily conceive, *The Brow of the Bethansheed* is fantasy painting at its most resplendent.

THE BROW OF THE BETHANSHEED (1995)
55CM X 31CM (22IN X 12IN)
'In faerie folklore, there is said to be a hill that has a gateway of trees over a hidden path. Walking through this gateway leads you to the Faerie Kingdom. But that can be entered only with the permission of the Faerie Guardian who hides in the trees. This Guardian is called the Bethansheed; he is always watchful, and can make the path appear or disappear at will.'

CHAPTER THREE

OF DRAGONS AND DREAMS

FANTASY IS AT THE CORE of virtually everything Sudworth paints. Even her landscapes and Still Lifes are imbued with its keen scent; only some of her early racing scenes are wholly naturalistic. This chapter, however, concerns her painting of overtly fantasy subjects, from mythological beasts such as dragons and unicorns to humans like wizards, sorcerers – and sorceresses.

What differentiates these pictures from the products of the majority of today's fantasy illustrators and painters is not so much the subject matter as her conceptual approach. Sudworth has – like many of us – her own personal mythology, which colours her work and the way she *sees* what is around her. Her approach to fantasy subjects is thus quite distinctly her own; although some of those subjects – dragons, for example – are frequently tackled by other painters, it is as if she has evolved independently the concept 'dragon', so that the particular dragons she paints resemble only superficially the creatures we're accustomed to seeing elsewhere.

This subtle point is perhaps best further explained by use of an analogy from high fantasy in its written form. We all know that J.R.R. Tolkien's *The Lord of the Rings* (1954–5) has spawned countless imitators, imitators of imitators, and so *ad infinitum*; collectively, these form the vast bulk of the literary subgenre that is called 'high fantasy' by enthusiasts, publishers, booksellers and 'genre fantasy' (or even 'generic fantasy') by the rest of us. Most of these attempted Tolkien clones are very similar to each other, all being set in a stock environment – 'Fantasyland' – and peopled by stock characters.[9] There are, however, some writers who handle material similar to Tolkien's but whose approach is entirely their

own; one example is Tad Williams, with *The Dragonbone Chair* (1988) and its sequels. One can draw comparisons between the works of the two writers, but Williams's voice is his own. In a similar way, Sudworth's straightforwardly fantasy paintings differ from others you will see because the path she has followed to reach here has wound through different terrain.

A further distinction between Sudworth and others working in the fantasy genre is more mundane. She brings to her fantasy paintings all of the compositional skills and techniques that she deploys to fantasticate her superficially realistic work. Since the subjects of these paintings are themselves fantastic, one is experiencing two levels of fantasy overlayered upon each other.

A fine example of her conceptual individualism is *Guardians of the Path* (see opposite). The composition itself is unusual for a fantasy painting,

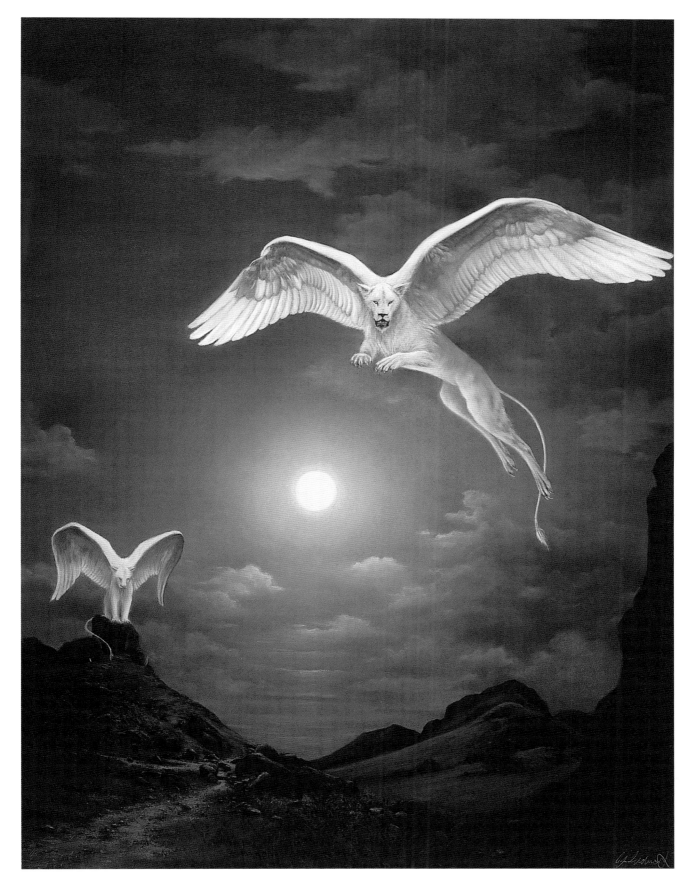

GUARDIANS OF THE PATH (1994)
110CM X 79CM (43IN X 31IN)

'*For me, this is a very ethereal, magical piece. It took me a long time to do it, and at one stage I stopped working on it altogether. After a month I went back to it, and then finished it quite quickly. I wanted the moon to be the centre of the picture, and the flying Guardian, the clouds and the land to sweep around it in an almost circular composition.*'

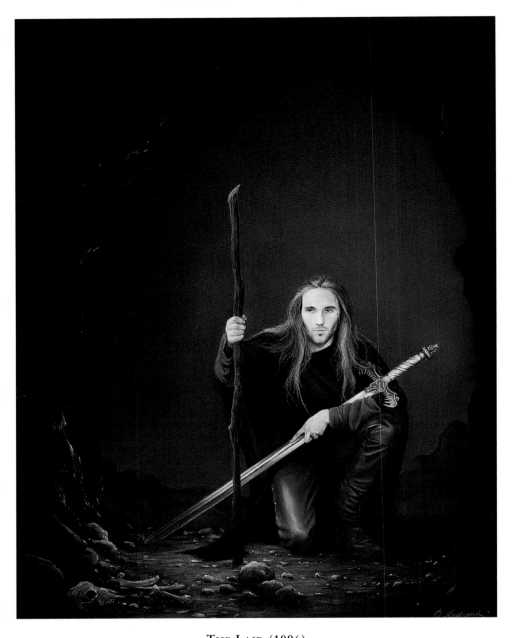

THE LAIR (1996)

84CM X 63CM (33IN X 25IN)

'I decided to keep the composition simple but strong, as I didn't want anything to detract from the figure. Warren [Hudson] sat for me and was, as always, an exceedingly patient model.'

with the central portion having a strong, circular construction; most fantasy paintings are cover illustrations, cards, posters, etc., and therefore geared to the rectangle. But more significant in the present context is the nature of the creatures themselves. They are flying cats – although on closer examination they're not even cats: their very long tails, tufted at the end, are more like those of gibbons and their faces are those of lions or tigers. There are flying cats in Egyptian mythology, but there is nothing of the Egyptian in these: they seem to belong exclusively to Sudworth's own personal mental zoo. Their pallor marks them as not physical, yet in other ways they are very physical. It would be better, perhaps, to think of them not as cats at all but in terms of Sudworth's mythology – that is, as Guardians, which may take any animal form they choose:

I think if anything has wings, especially white or translucent wings, this suggests something very spiritual or mystical. Cats are very graceful

THE SNOW DRAGON (1999)
51CM X 79CM (20IN X 31IN)

'The dragon in this scene takes up only a tiny fraction of the picture and is almost lost amid the mountains. I wanted the landscape to seem vast and wild, with the dragon a long way into the distance. I didn't feel that a dark sky would complement the blues of the snowy mountains, so I decided to make this sky hazier with the moon very yellow – the moon often appears a much stronger colour when the land is covered in snow.'

and powerful, particularly the big cats. Flight suggests freedom. Put the two sets of characteristics together and they make a very formidable yet beautiful creature. There are Guardians in many of my pictures, but these are among my favourites. They are wild, untameable and indestructible.

By contrast, *The Lair* (see opposite) is conceptually a much less complex piece. Paradoxically, however, it is complicated to analyse, insofar as it preys less upon our straightforward emotions than upon our intellectual faculties. Ostensibly this is just an atmospheric mood piece – superbly

Overleaf:
MERLIN (1998)
73CM X 98CM (29IN X 39IN)

'Merlin (Welsh name Myrddin) is the archetypal mage, the master of magic and wisdom, and that is what I wanted to capture in this picture. He is one of the most enigmatic and compelling figures of British mythology.'

49

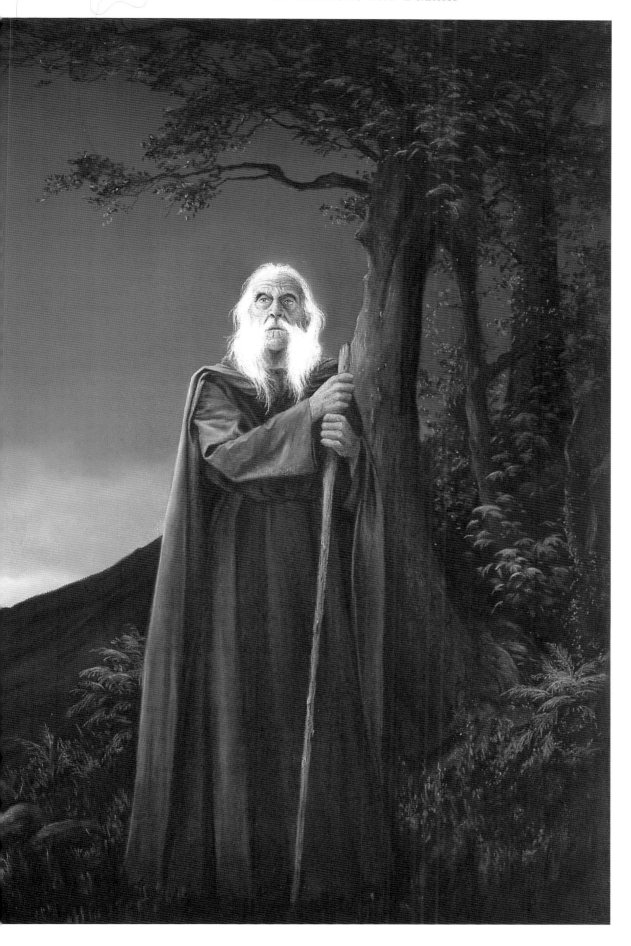

THE MAN UNDER THE TREE (1993)

52CM X 71CM (20IN X 28IN)

'At first glance, this picture looks like one of my Earth Light
trees. But beneath the tree, a tiny hooded figure is holding up a
lamp, which illuminates the tree. In ancient times, certain
features in the land were considered powerful and special.
These places were sacred and were believed to have spiritual
Guardians who watched over them. Sometimes a person
would be chosen to be a physical Guardian of a particular site.
The title has two meanings. The first is the obvious one:
a man stands under the tree. But there is also a more symbolic
meaning. We will never be more powerful than nature.
We must learn to live in harmony and be part of it;
we will never control it.'

executed, especially the sky colours, the leather folds and the wary *presence* of the kneeling figure's facial expression. Yet there's a tremendous amount of *story* wrapped up here. The title is *The Lair*, yet whose lair are we talking about? Is the man looking into his own lair or that of someone else, or of some wild creature? Everything about the picture suggests some imagined Golden Age of the remote past or an alternate fantasy world, yet the style of the clothing suggests the designed archaism of modernity. We've caught the watcher in the mouth of the lair some*where* and some*when*; exactly in which world or which eon is something we cannot deduce. And yet the curious aspect of this painting is that we do not feel in the slightest *distanced* from the figure; at some gut level, we know precisely the where and the when. Incapable of coping with so many analytical paradoxes at once, the intellect gives up the struggle, so that, in the end, the painting's impact on us is an emotional one after all.

The composition is intriguing, too, and it represents the end-result of a fair amount of experimentation:

Originally, I had planned for Warren [Hudson, who modelled for this picture] to hold a lamp or torch in his hand, with a sword resting across his arm and knee. We were lucky with the sword, as friends were kind enough to lend us a particularly beautiful one. Finding a suitable lamp proved more of a problem; whatever we tried just didn't seem right. Then Warren suggested he should have a staff as well as a sword. At first I wasn't convinced about this – I thought it might look wrong – but after we discussed it, I decided it could work rather well.

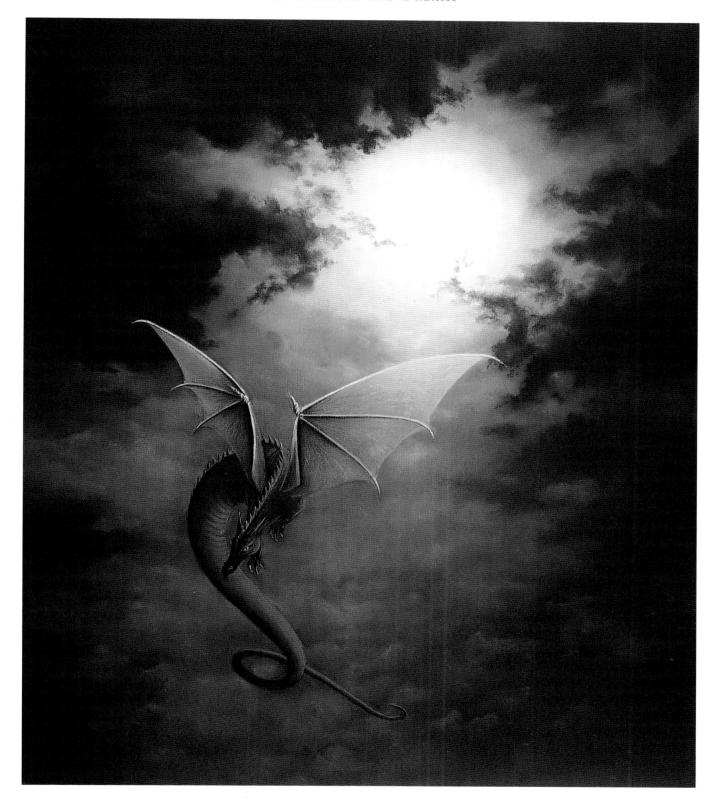

OUT OF THE LIGHT (1996)
63CM X 55CM (25IN X 22IN)

*'In many fantasies and fairy stories, the dragon is a fire-breathing creature, the smoke and flames being a part of him.
In this piece, I wanted an external fire – and to portray him almost coming out of the sun. He is, in some ways, part-dragon and,
in others, part-salamander or fire elemental. The composition is a very simple one; I feel that the strongest part of it is not actually
the dragon, but the almost invisible sun. The black edges of the clouds around it are sharp, as if the sun had only just broken
through them to release the dragon from its light.'*

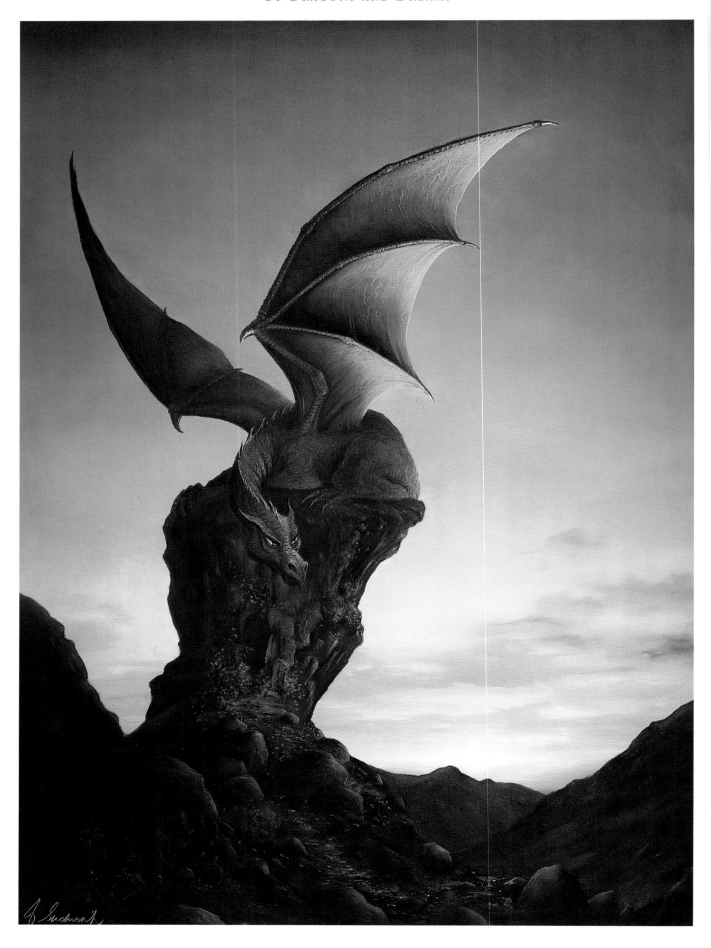

DRAGON'S DAWN (1998)
83CM X 61CM (33IN X 24IN)
'*Essentially this is a picture about guardianship. More than just the dawn belongs to this dragon, for he is a creature of both air and land. In my picture, he is watching over the cave and stony path beneath him, as well as the rock he crouches on. I wanted to suggest that the cave concealed something or someone, so that it was not just his own resting place he was guarding. In many stories and legends, it is in the most inhospitable and unlikely places that the greatest secrets, treasures or enlightenment can be found. I wanted a very simple composition so nothing would detract from the dragon's outline. For this reason, I restricted any detail in the sky to the area below him. I also liked the idea of him looking down on everything, including the dawn.*'

In fact, I feel now that the staff helps the picture a lot; its strong vertical shape gives strength to the composition and the figure. It draws attention to the harder, sharper edge of the sword.

Merlin (see pages 50–51) is a much more conventional piece, its main strength lying in the fact that it is quite simply a beautiful painting. Its sharpness and the clarity of the sky colours add a touch of magic realism to the effect, a hyper-reality to be juxtaposed with the remote, mythical nature of the painting's subject and the murkiness of the hillside and forest's edge. The picture itself plays with time in our minds, as does its dominant figure. About it, Sudworth says:

There's something very special about Merlin. To some, he is an historical figure while to others he is a character of romantic myth. Sometimes he is a guardian of the land, the wild man of the forest. He is or can be many things.

The picture took quite a long time to do, and for a while I wasn't sure if I had made the expanse of sky too vast. But I decided it was right for the mood I wanted to create. Merlin stands to the side of the picture, taking up only a small piece of the composition, yet his figure dominates it. I wanted the face to be old with years, yet still powerful and strong. It wasn't based on anyone; it's simply how I imagine Merlin to be.

This combination of dominance and unobtrusiveness is, indeed, a characteristic of Merlin. He is really the central figure of the Arthurian cycle of legends, and yet he almost always plays a background role – and it is pleasing to see it so expertly caught in a visual image.

Out of the Light (see page 53) is astonishing. It is one of the most unusual dragon pictures I have seen and, through its conceptual juxtapositions, an extraordinarily powerful evocation of the displacement that lies at the heart of the fantasy mood.

What first strikes the viewer are its colours. Deep browns and reds predominate, giving the impression of distant flames reflected in a cloudy night sky. Indeed, these colours have been used by the painters of countless different schools, from the Impressionists to modern illustrators, to denote the night sky. And yet the focus of this particular depiction of a sky is the white-hot blaze of the sun, thrusting back the reluctant clouds. The dragon itself, although clearly a creature of great might, is here fluttering like a flimsy moth in candlelight. The composition and the painting's title in conjunction inevitably lead one's thoughts towards Icarus, yet there is no sense that this dragon is helplessly plummeting from the sun's heat – no sense, indeed, that it is in any way at all distressed. This is at the same time an archetypal dragon picture and utterly original.

Overleaf:
BLACK DRAGON (1996)
80CM X 110CM (31IN X 43IN)
'*Dragons are the most magical and wonderful of creatures. They appear from a very early time in history in stories and legends from all over the world. They seem to fascinate anyone who has an active imagination. The Black Dragon isn't based on any particular legend or story; I painted him just for myself.*'

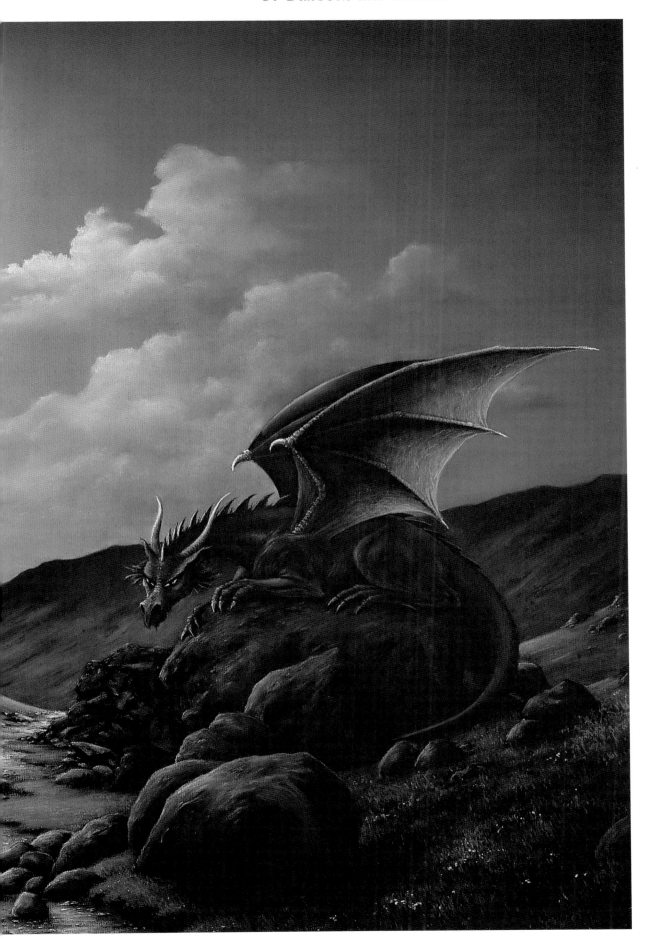

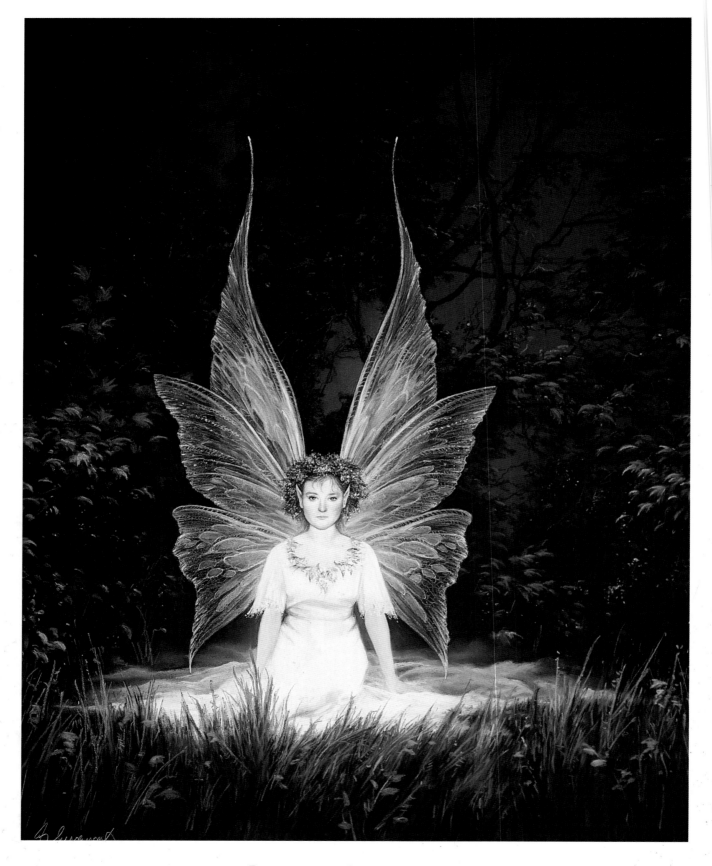

BREATH OF THE BRIGHT FEY (1998)
83CM X 67CM (33IN X 26IN)
'*Though she is neither aggressive nor threatening, I wanted her to have an air of power and magic.*'

The colour values of *The Snow Dragon* (see page 49) are diametrically opposite to those of *Out of the Light*; here, heat has become cold. Although there are a few muted purple-reds in the sky, what dominates is the icy Arctic blue of the landscape. Presumably to symbolize that it is inseparable from the terrain it inhabits, the dragon itself is depicted using the same scheme of blues. The creature in *Dragon's Dawn* (see page 54) is done in more conventional hues; we can almost hear it hissing, disturbed by our clumsy intrusion in the cold, early morning light.

Black Dragon (see pages 56–7) is another major painting on the dragon theme. It is best described in Sudworth's own words:

> *This picture took several weeks to complete and is quite large. I wanted the dragon to be a part of the landscape rather than depicted in flight. I decided to paint him crouching down on a rock, his body blending with the large boulders around him so that he is almost camouflaged by them. Although the dragon is in semi-darkness, I tried to put in as much detail as possible, especially on the head and wings.*
>
> *The landscape is also very detailed, particularly the boulders and rocks. Much of my inspiration for the landscape came from Buttermere and other parts of the Lake District. Quite often, in the natural landscape, you find rock faces and stones that resemble people or animals. Some of them look almost man-made, like giant statues, and can be quite striking. With this in mind, I decided to make the large outcrop on the top of the hill very roughly in the shape of two bears sitting next to each other, though not everyone will see them.*
>
> *Although the dragon is the main subject, I wanted both him and the landscape to be equally strong, so that neither would detract from the other, and the viewer's eye would be drawn, in turn, to different parts of the picture.*

It hardly needs to be added that this has proved to be one of Sudworth's most perennially popular paintings.

Although much more recent, *Breath of the Bright Fey* (see opposite) has swiftly established itself as another. It is, yet again, difficult to define exactly what it is that makes this picture so appealing; it seems to touch a chord somewhere at the very core of that primordial knot of our subconscious which is somewhat inadequately termed folk memory. That this should be so

seems at first paradoxical, because in many of her visual aspects – the graciously curved, elaborately formed and filigreed gauzy wings in particular – the fairy caught here by the painter's eye owes more to Victorian concepts of Elf-land than to any older folk tradition. Her clothing, however, owes nothing to Victorian style: she is quite a scruffy little fairy. Her face has something of the brute rebellion and spoilt grumpiness of the pre-adolescent. In a way, she's reminiscent of the child who's just the wrong age to have been appointed bridesmaid, and who is toughing it out in the teeth of the wedding party's poorly concealed realization of that fact. In many respects, of course, the fairies of the older tradition behaved precisely like spoilt pre-adolescents; perhaps that is what we respond to in this portrait, and what stirs such a feeling of recognition.

'Fey' is an unusual variant spelling of the word 'fay', but it permits a conceptual pun in our

Overleaf:

WATCHING THE DAWN (1999)

65CM X 84CM (26IN X 33IN)

'*I wanted the fairy here to be along the same lines as the one in* Breath of the Bright Fey. *But in this picture, I wanted her to be more a part of the landscape than the whole of the scene. She is based on my sister, Deborah; with her delicate face and air of wistfulness, Deborah was exactly right.*'

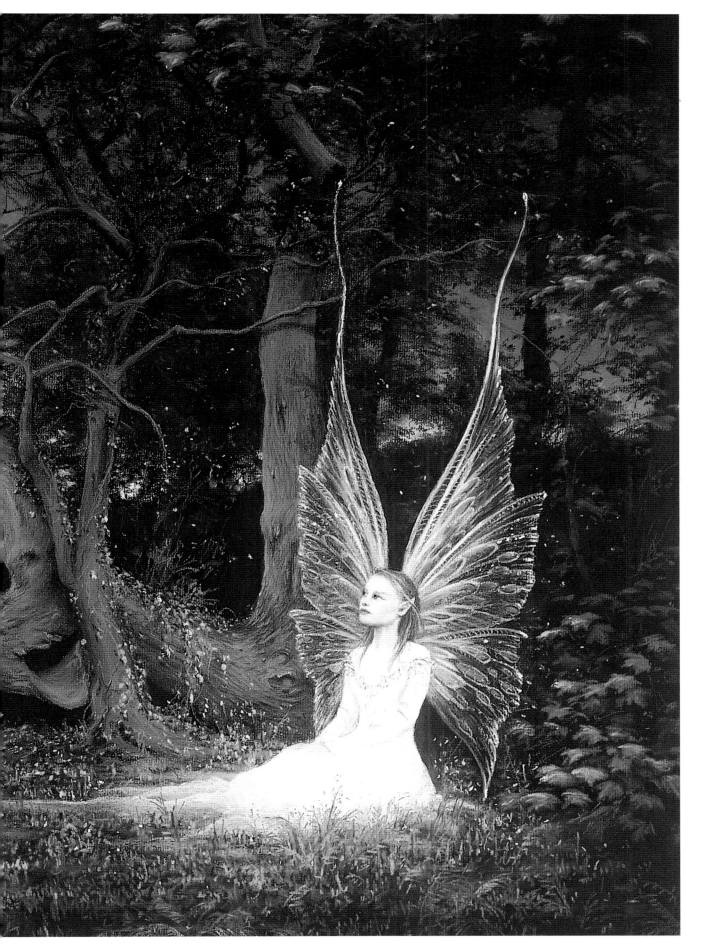

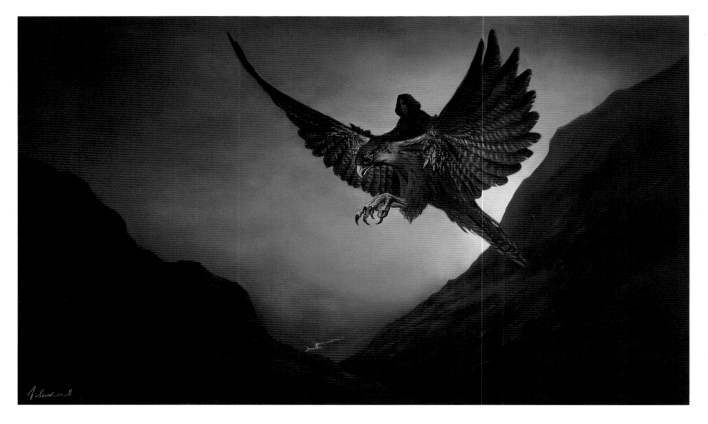

SHAMAN (1997)

51CM X 86CM (20IN X 34IN)

'I was interested in the idea that shamans were said to leave their bodies and fly, sometimes taking on the mantle of a huge bird. They were said to be able to commune with the spirits as well as understand animals and possess psychic abilities. It was the idea of flight, both physical and spiritual, which I wanted to convey. I tried to create the impression of being very high up in the mountains, moving in and out of the clouds – these themselves often represent the boundary between this world and the next. The landscape was inspired by Honister Pass.'

reaction to this painting. No wraithlike, ethereal Pre-Raphaelite lovely, this fairy is very real and solid in some respects; she has the plumpness of puppy fat – another adolescent signal – yet what impresses us most is her feyness, in the Scottish sense of that word, which does not imply death tendencies but rather refers to a sly non-human strangeness. We can tell from her face that she resents our intrusion, yet is resigned to simply waiting where she is until we go away and she can resume again the activities we interrupted.

Sudworth's own thoughts on this important painting are revealing:

I wanted to make her appear very translucent and ethereal, while at the same time remaining solid and real. She is a fairy of woodland and forest, and sits among her trees in the long grasses. She is a Guardian of the forest, her home and her domain. She is wearing a crown of hawthorn, *which is traditionally considered to be a very powerful protector, in that it is believed that nothing bad can live in a hawthorn. The hawthorn is also said to be one of the most magical trees.*

The wings took a long time to do. I looked at many different kinds of wings, particularly dragonfly wings, but I knew how I wanted them to appear. I wanted them to be believable and real, yet at the same time magical and diaphanous. I made the fairy's face and head-dress stronger and clearer than the rest of the body, so that it would give the illusion that she was not quite as solid as a mortal might be. To augment this idea, I made the edges of her dress fade into a mist around her.

Another of those pictures that devotees tend immediately to think of when Sudworth's name is mentioned is *The Edge of the World* (see opposite). It is a measure both of Sudworth's skill and

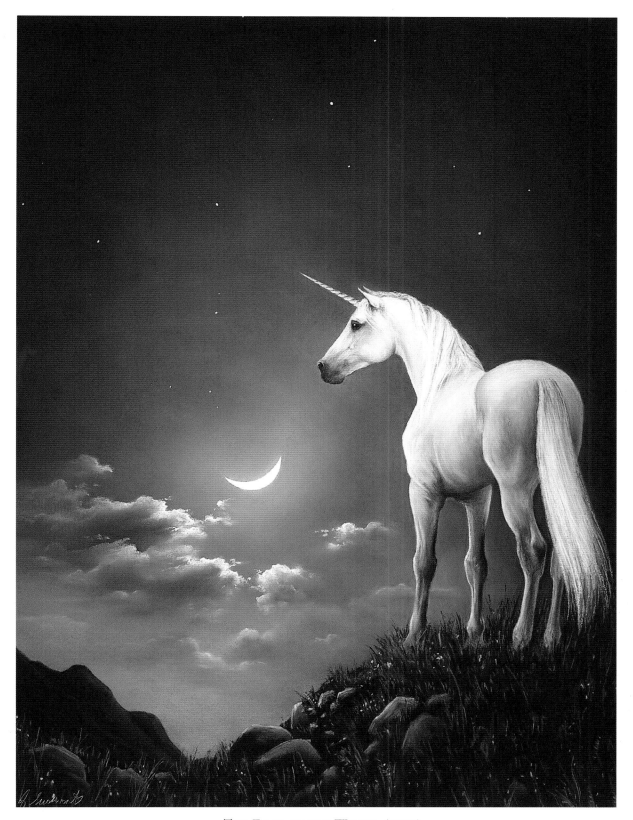

THE EDGE OF THE WORLD (1998)
81CM X 59CM (32IN X 23IN)

'I had decided to portray my unicorn against a moonlit sky, but at first I wasn't sure what sort of landscape he should be in.
I tried to imagine him in various different settings and knew that I wanted something very simple and uncluttered, yet special:
a place that was inaccessible or perhaps did not exist in the everyday world. So I decided he should be at the edge of the world,
standing at the very rim of a grassy hill with the vast sky ahead of him.'

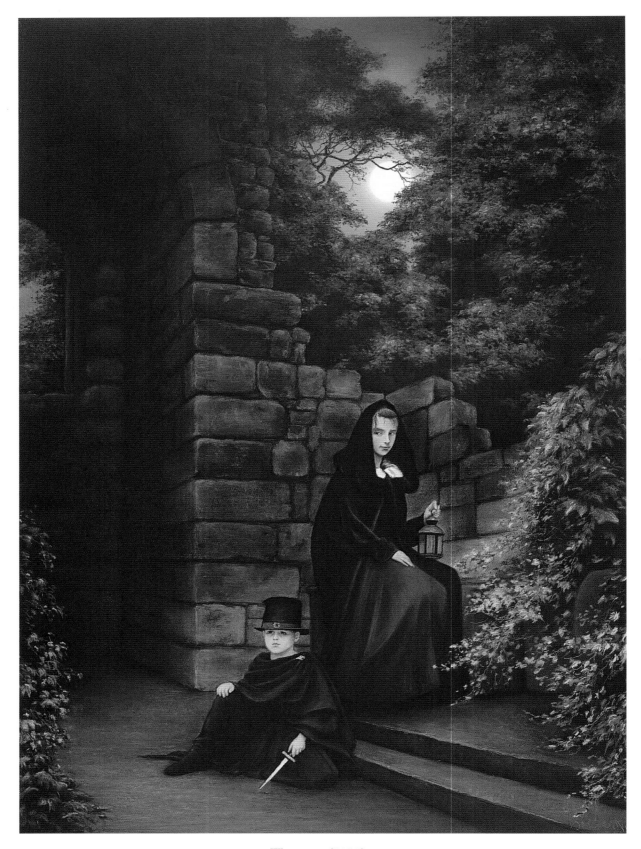

WAITING (1995)

120CM X 84CM (47IN X 33IN)

'The background was partly inspired by the ruins of Windle Abbey, which look very much like the remains of a
castle. The children who sat for me, Jenny and Sean, were exceptionally good models. I did a lot of quick studies,
both in the studio and outside. This picture was later bought by Jenny and Sean's grandmother; unfortunately,
all the original sketches have gone missing.'

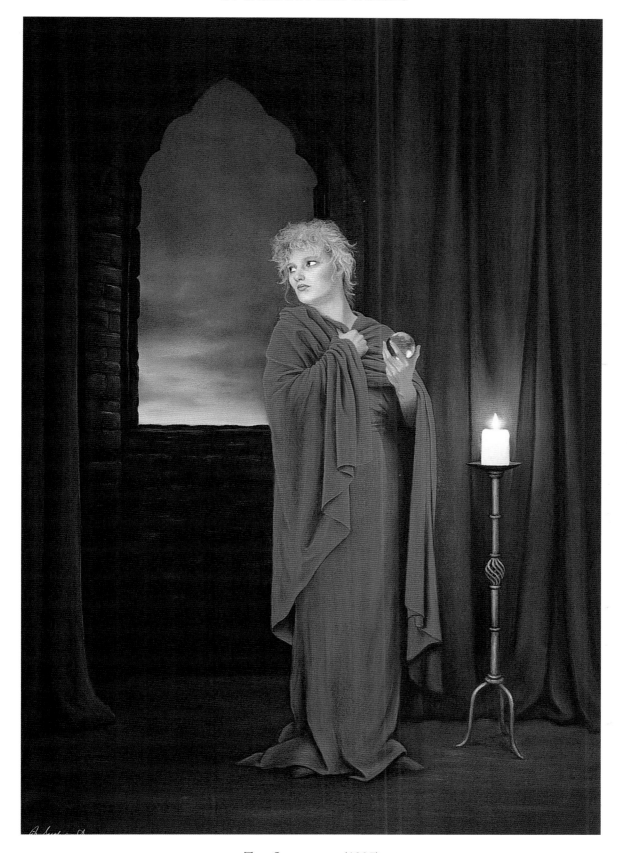

THE SORCERESS (1997)

94CM X 62CM (37IN X 24IN)

*'This picture was inspired by a visit to Furness Abbey. There was one particular window in a very dark little room
and I could just imagine it with beautiful drapes and a candle and some kind of mysterious figure there.
So I decided to paint it occupied by a woman – a strong woman.'*

of her individualistic vision that this should be so. For, at the cusp of the twentieth and twenty-first centuries, unicorns are as prevalent and generally about as aesthetically rewarding in fantasy art as beanie babies are in the mundane world. 'You can always sell a unicorn,' you can imagine the grizzled professional marketing men saying as they prepare to launch yet another hackneyedly 'tasteful' unicorn picture, in collectable-card or poster form, into the maw of a hungry market. There are unicorns running in groups through breaking waves, bathing in waterfalls, prancing beneath rainbowed skies, dramatically silhouetted on rocky outcrops against a background that looks like Fantasyland's equivalent of the Grand Canyon...there seems to be no end to the clichés.

In this context, it is almost impossible to bring freshness to a unicorn picture, and yet somehow Sudworth succeeds. Even more astonishingly, she succeeds despite the fact that *The Edge of the World* is almost a straightforward portrait – or perhaps that is the reason *why* she succeeds. Of course, she has been devoted to horses all of her life, and her paintings of them reflect this. All her knowledge of the workings and physiology of these animals has been brought to bear in her depiction of the unicorn; in fact, she used her own horse, Dilly, as the model for the painting. Many of her pictures present us with perceptual dichotomies; the dichotomy here is that, while we know the unicorn is a creature of fantasy, the one in this picture is so very genuinely *real*. So many other painted unicorns are *pretty* in the sense of dollops of candy floss, but this unicorn has the beauty of firm corporeality.

Reality also is the foundation of the fantasy ambience of another powerful painting, this time thoroughly set in the mundane world: *Waiting* (see page 64). Although the children are realistically depicted and there is nothing spectral about them or the background that one can quite pin down, there can be no doubt that – at least in *my* mind – this is a ghost painting: it is as if Sudworth had set out to paint the ambience of M.R. James's stories. The period clothing is a part of this; and so are the dagger placed in the little boy's hand and the slightly other-worldly expressions on both of the children's faces. The fragment of ruined wall seems spectral and isolated from the tangible world, although, just like the figures of the children themselves, it was in fact taken from life.

There are subtler interplays than these to be found in the painting, as Sudworth explains:

I am fascinated by the idea of the most unlikely people, such as young children, appearing strong and powerful. I wanted the children to seem more like predators than prey. Whether they are ghosts, Guardians or just special I leave to the imagination.

I think it's obvious from their expressions and poses that they are no ordinary children. They are unafraid and unconcerned – they are waiting. I added a lamp that has not been lit to suggest that perhaps, unlike most children, they are unafraid of the dark.

The figure in *The Sorceress* (see page 65) is likewise immediately recognizable as someone *special*. Once again, as in *Breath of the Bright Fey*, we have that paradoxical juxtaposition of the fey with solid physicality – for there is no doubt in our minds that the Sorceress is a fully alive and breathing woman (the figure is actually a portrait): she has mass, yet at the same time she is not wholly of this world. It might have been tempting to surround her with sorcerous paraphernalia, but the only magical feature here is the crystal ball she's holding, and even then she is not looking at it, her intent gaze instead being directed to something that *we cannot see* – something unpainted yet part of the painting. Fantasy should concern itself with what is beyond, what is at our fingertips but somehow still unattainable, and here that concept is translated into visual and dramatic terms – dramatic also in that the facial expression, dress and body language are all reminiscent of some classic stage performance: Ellen Terry as Lady Macbeth, perhaps.

Sudworth thought through the character of the Sorceress in some considerable detail before attempting to portray her:

Many of my paintings depict archetypal characters or Guardians – figures that symbolize goodness and suggest protection. In The Sorceress *there is a suggestion of something*

Facing page:
THE WIZARD (1997)
91CM X 63CM (36IN X 25IN)
'*Wizards can be good or evil; this one is most certainly on the side of good. As well as being a worker of magic, he is the strongest knight and the ultimate force against evil.*'

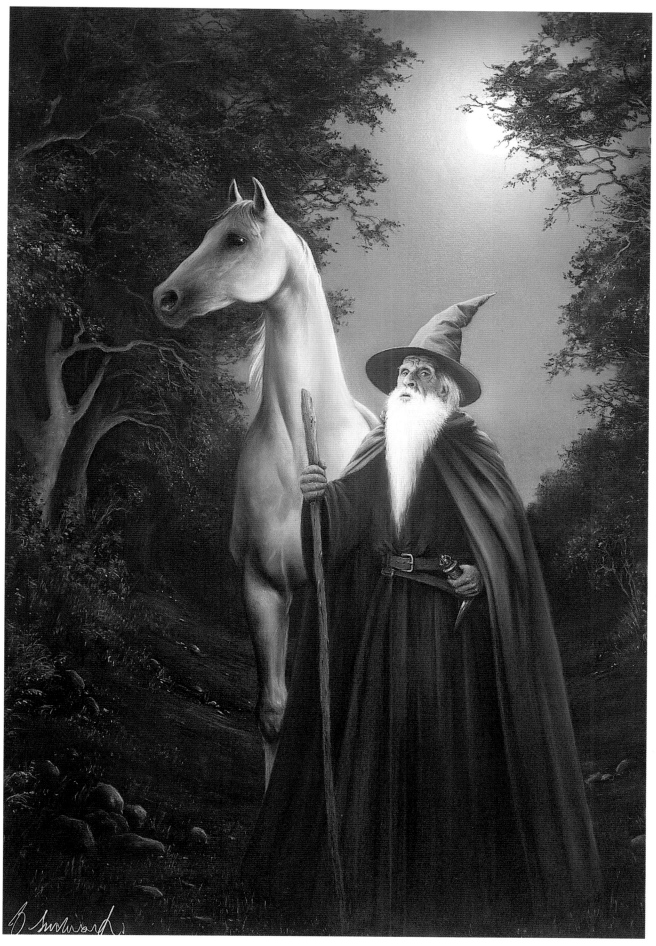

SHADOW (1999)

65CM X 53CM (26IN X 21IN)

'In this picture, I wanted to leave it open to interpretation as to whether the huge black wings are part of the figure or instead perhaps belong to something else.'

totally different. Though not entirely evil, neither is she altogether good. I wanted to create an air of tension and the feeling that she is perhaps not all that she seems. She is a manipulator, yet a victim of her own wishes and desires, prepared to meddle in other peoples' lives to realize her own ambition. She is...well, a sorceress. In many myths and legends, the sorceress is a dangerous, power-hungry figure. In the Arthurian legends, for example, it is a sorceress who is the downfall of Merlin.

In other words, this is a lady who, when she is naughty, can be very naughty indeed. The practicalities of the painting were also a matter of deep concern:

I painted the Sorceress and the candle together and afterwards put in the background from sketches I'd made while we'd been at Furness Abbey. In the studio, the Sorceress's gown was basically a small piece of red velvet, which I had to try to make look like yards of fabric. This required some creative drapery, as well as a vivid imagination! I kept the sky fairly dark and cloudy, partly to add atmosphere to the scene, but also so that the candle would remain the strongest light source.

To match the dangerousness of the unpredictable Sorceress – perhaps to try to keep her under control – there is a much more staid figure in *The*

Wizard (see page 67). The figure here is of a quintessential fantasy wizard – although, that said, Sudworth did consciously borrow many characteristics from Tolkien's Gandalf as a way of acknowledging the pivotal part his creation plays in our conception of high-fantasy wizards in general.

The Wizard's horse is a portrait of Sudworth's own horse Dilly; he seems, to judge by his posture and the angle of his gaze, more companion of than servant to the Wizard, capable of thinking his own thoughts even while obeying the Wizard's commands. The leafy branches around the moon and the moonlight-filled sky form a profoundly feminine shape, a reminder that, while men may draw great powers to themselves, the Goddess – and her fertility – is the mainspring of all worldly pursuits.

In her overtly fantastic paintings, as in all her others, Sudworth is ever a master of nuance. Just when we feel that we have noticed every last little touch, another suddenly springs up to force us to re-evaluate our conclusions, to make our understanding of the picture more complete or to alter it altogether. This depth of symbolism is unusual in modern fantasy painting, and harks back to the painterly conventions of earlier eras, where so often a scene was peppered with symbols that mean little to most of us today but were laden with significance in their day. Sudworth has drawn attention to the unlit lamp of *Waiting*, but her fantasy paintings are full of such subtle hints at the otherly, such symbols of the beyond.

All we need is eyes to see them.

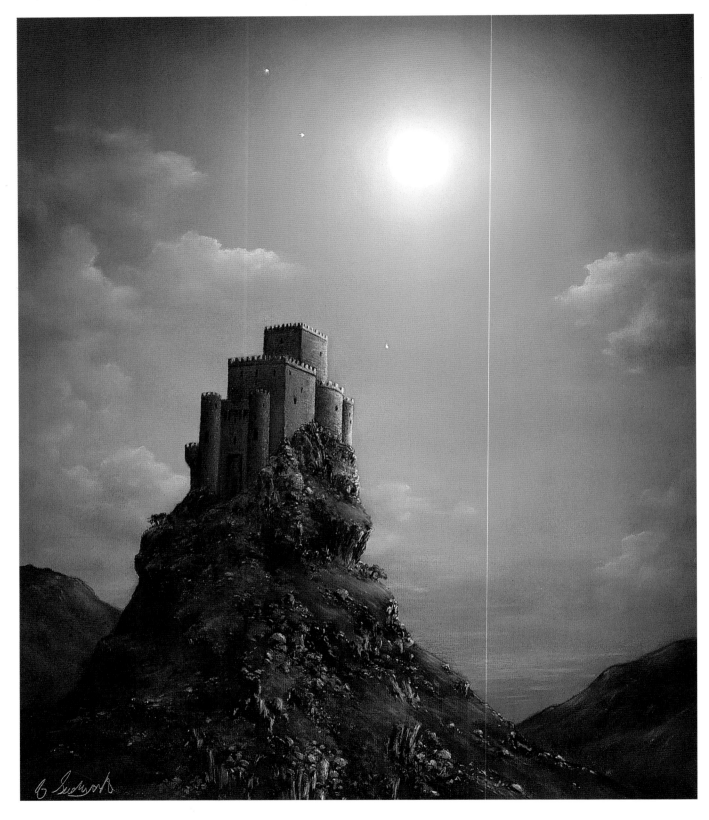

THE CASTLE (1995)

76CM X 64CM (30IN X 25IN)

*'For this picture I looked at various castles, making several studies of different styles.
I decided to use a Norman-type design, with strong straight walls and battlements.
The one in the painting isn't based on any existing castle in particular.'*

\mathscr{O}F \mathscr{S}PIRIT AND \mathscr{S}TONE

\mathscr{A}RTHUR C. CLARKE'S well-known adage runs: any sufficiently advanced technology is indistinguishable from magic. When he said this, he was thinking of present-day humankind being confronted by vastly superior alien technology, but obviously the same would apply if one of our distant ancestors were brought by time machine from the remote past into our present. Items that we take for granted – from simple things like matches to more complicated gadgets like telephones and on to far, far more complexity – would to him seem incomprehensible except in terms of magic. What is not quite so obvious is that Clarke's 'law' also works if the arrow of time is reversed, even if for contrasting reasons: the further back in time we look, the more magical the past seems to us. In other words, the less advanced the technology, the more we imagine there must have been room in the world for magic.[10]

But this is not the only element in the complex of emotional effects that truly ancient sites – ruins, stone circles and the like – have upon us. In a way, perhaps we find it easier to feel a rapport with the people of the archaeological past than with those of more recent eras. Looking at an eighteenth-century home, we imagine – quite wrongly, of course – that the people who lived in it were essentially exactly the same as us and their lives were just like ours, albeit without television, modern medicine, etc. We make no imaginative leap to try to comprehend what their lives and indeed *they themselves* were actually like. But, looking at a burial mound that dates back thousands of years, we *have* to bring our imaginations into play if we're to create a mental picture of its builders and their world, and once the imagination has kicked in it starts to conjure up all sorts of other – entirely hypothetical and almost certainly fallacious – images of those people.

It starts to conjure up ghosts, in a way…And those ghosts, while they may be entirely figments of our imagination, can seem very real to us. Hence the feeling, when we see the truly ancient, that we're connecting so directly with the people who once dwelt there.

There is, however, much more to the magic of ancient structures than this. Their sites seem to have been chosen very carefully for their magical qualities – even if, like so many of the megaliths, the structures were designed for what we would now call scientific (astronomical) reasons, we have to remember that, in worldviews other than our own, there is no real distinction between science and magic. If – as Sudworth maintains – the earth itself has magic, a spirit, and is the source of the Earth Light that surrounds trees, then the ruins our ancestors left behind them can be seen as the loci or foci (or both) of that magic.

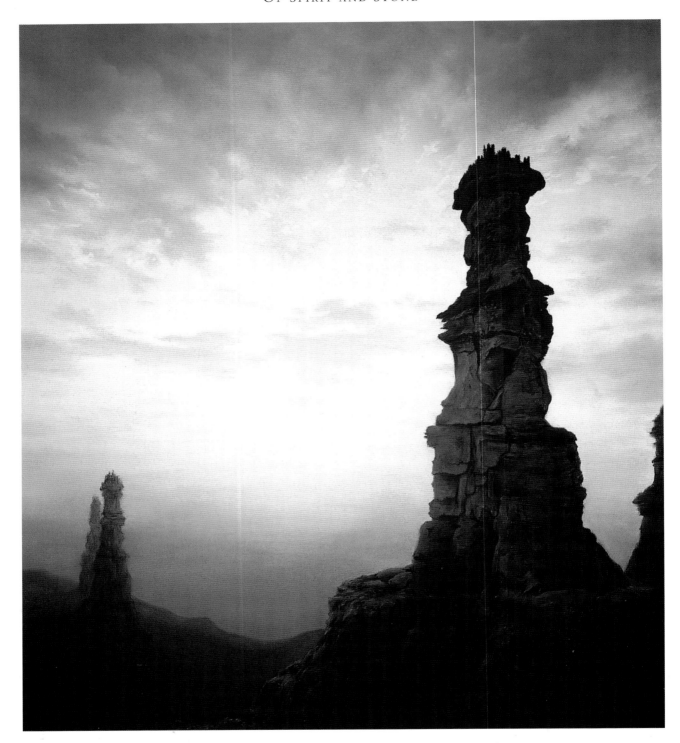

Above:
SANCTUARY (1994)
62CM X 53CM (24IN X 21IN)
'Sanctuary is based on a small picture I used to love as a child. It was in one of my father's walking books, and showed a cairn, or pile of rocks, which walkers and climbers use to mark paths. But I always imagined it as a huge tower of broken stone with an impenetrable fortress or castle on top.'

Right:
GIANTS' DANCE (1998)
67CM X 45CM (26IN X 18IN)
'This is the first picture of my Stone Temple Trilogy. On a technical note, I did not want to portray a particular constellation in the scene, so I placed the stars randomly.'

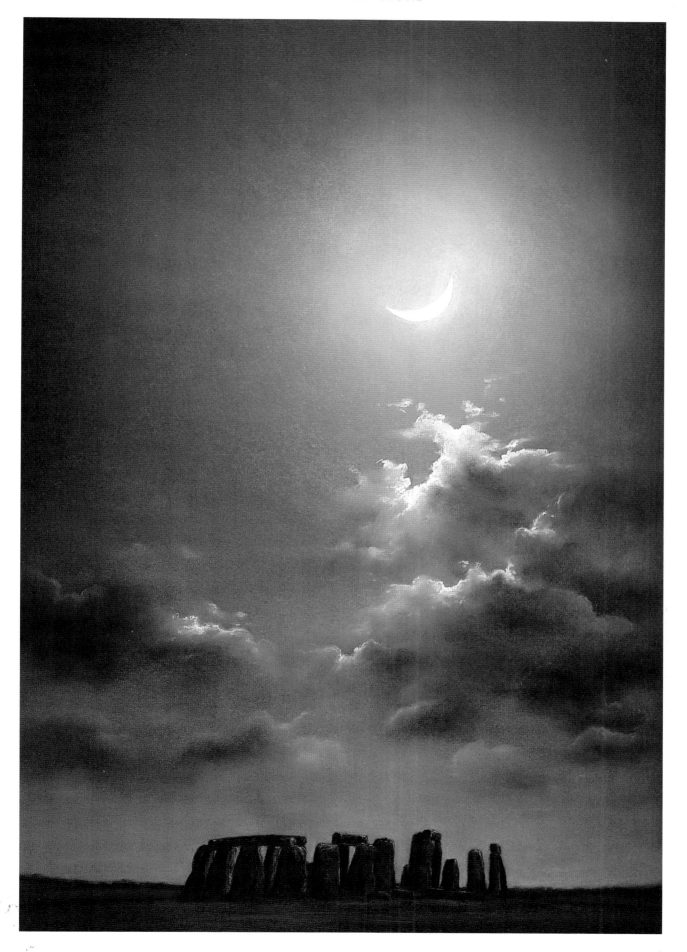

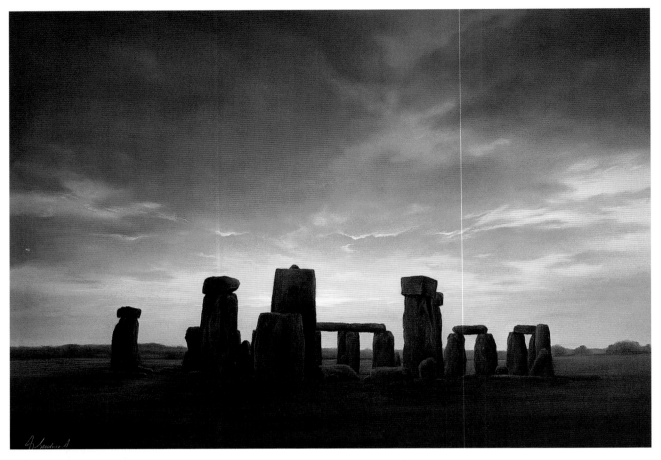

STONEHENGE (1999)

67CM X 80CM (26IN X 31IN)

*'I remember the first time I visited Stonehenge: I was bowled over by both its beauty and its atmosphere.
I felt very humble standing before it, yet overcome by a great sense of being part of something special.'*

And it is hard for even the most sceptical or literal-minded not to *feel* the magic of these places.

To the creative artist, the magic manifests itself as inspiration – for paintings, music, poetry, prose or works in any other medium. In this chapter, we look at some of the results of the inspiration they have given to one particular artist.

That inspiration need not always come from an obvious source. It was the photograph of a cairn in one of her father's books that eventually inspired Sudworth to paint *Sanctuary* (see page 72). Atop a colossal rock pillar that looks like one of those tall stacks that erosion can produce in desert areas, only here on a gigantic scale, perches a castle. Castles and fortresses are traditionally placed on high vantage points for defensive purposes, but here the idea has been taken to its extreme. In the distance, there are two further pillars, each presumably topped by its own fortress.

It is only after one has looked at this splendid painting for a while that one realizes the foreground fortress is inaccessible: there is no way of reaching the place except by air. How was it built? How does one reach it? Perhaps the inhabitants ride astride birds, or dragons, or other creatures – it is inconceivable that their technology encompasses aircraft, because in that case the fortress would be built differently – or maybe there is a secret stairway within the pillar. The matter remains a mystery, and really the picture isn't open to this kind of logical analysis. It depicts an idea, not a real place: 'To me, this is total sanctuary,' says Sudworth.

If the fortress in *Sanctuary* is imaginary, the subjects of Sudworth's *Stone Temple Trilogy* (*Giants' Dance, Castlerigg Stone Circle* and *Long Meg and Her Daughters*) are the opposite. Here the inspiration has been very direct – the megaliths in the paintings are real places, although the depiction of them is anything but photographic. About them, Sudworth says:

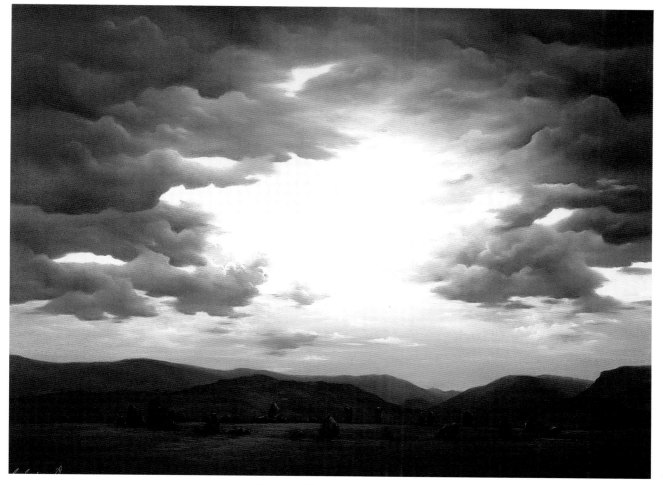

IN THE CLOUDS (1999)

66CM X 86CM (26IN X 34IN)

'I've painted Castlerigg Stone Circle many times. It's such an inspiring and exhilarating place – always enchanting, always different. In this picture, the stones are hardly visible against the dark land. I wanted the sky to seem vast and moody above them, almost as though a storm were gathering.'

In each piece the moon is in a different phase, starting with the waxing moon in Giants' Dance, *followed by the full moon in* Castlerigg Stone Circle *and ending with the waning moon in* Long Meg and Her Daughters. *I wanted to capture the wildness and power of these places, their energy and atmosphere, yet at the same time retain a sense of stillness and reverence.*

The subject of *Giants' Dance* (see page 73) is Stonehenge, the largest and best known megalithic monument in the British Isles. The history of Stonehenge goes back to 3000BC, when its first structures were built: the Aubry holes, the bank and the ditch. In about 2100BC, it is believed, the blue stones were erected. Archaeologists say the lintelled circle and horseshoe were started in about 2000BC, and that work continued on Stonehenge until about 1100BC.

In real life, the popularity of Stonehenge makes it hard to appreciate the magic of the site, for all kinds of restraints have been put upon visitors, who nevertheless congregate here in their thousands – complete with radios and screaming children. In her painting, however, Sudworth manages to capture the feeling which one experiences in only diluted form when visiting of the monument's ponderous serenity. The crescent moon reminds us that the original function of Stonehenge may have been as an astronomical observatory of some kind, and thus of its spiritual importance to the builders.

In connection with this painting, Sudworth is fond of quoting a poem written in 1823 by Thomas Stokes Salmon about Stonehenge:

Here oft, when Evening sheds her twilight ray,
And gilds with fainter beam departing day,

75

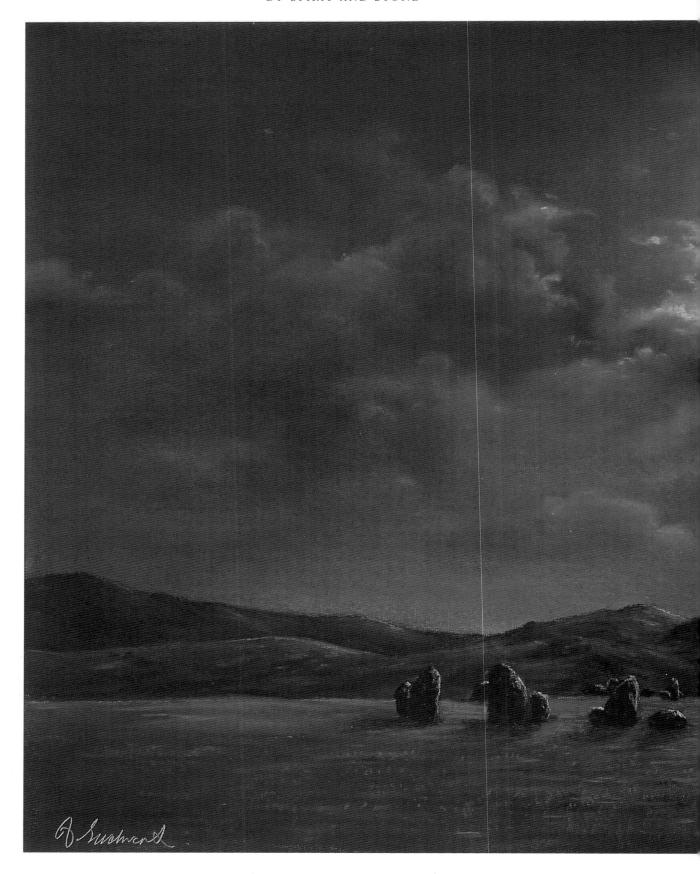

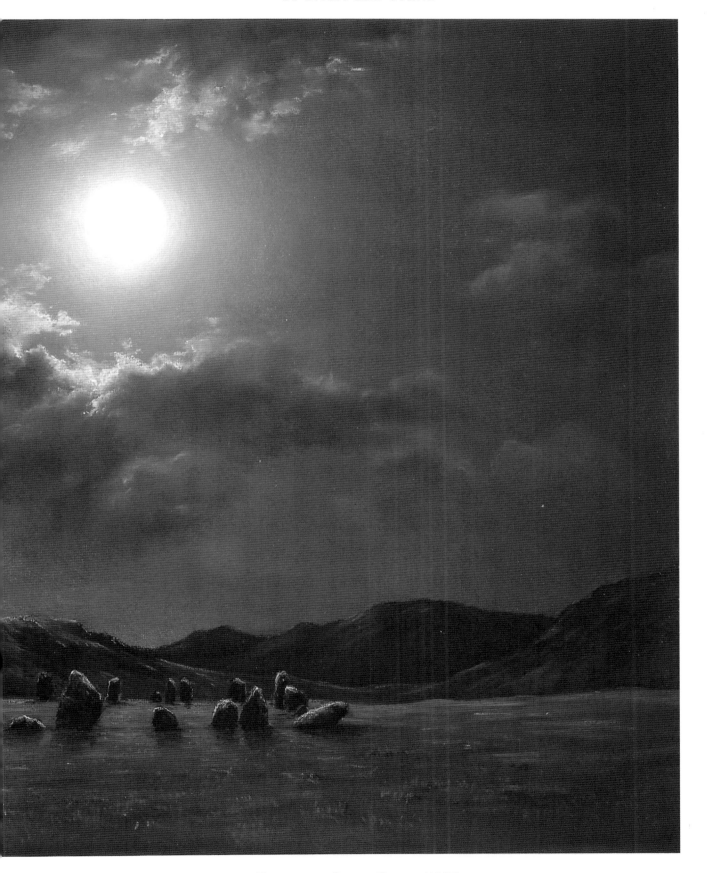

CASTLERIGG STONE CIRCLE (1997)
38CM X 64CM (15IN X 25IN)
'I really love this picture, because I'm very fond of the place it depicts. I didn't actually want to sell it, but it was sold the first time it was exhibited on the opening night of my Dreams and Whispers *exhibition.'*

BRIGIDA'S VALLEY (1998)
59CM X 40CM (23IN X 16IN)
'*Although the legend is very dark, I wanted the picture to have a fire and
warmth to contrast with the darkness.*'

Facing page:
LONG MEG AND HER DAUGHTERS (1999)
65CM X 43CM (26IN X 17IN)
'*I wanted Long Meg to be closer to the foreground than the rest of the stones, though this
means that you can't see the whole circle.*'

THE LAST HOUSE (1995)

66CM X 48CM (26IN X 19IN)

*'This is a very dark picture. Though not unpleasant, the real Last House was a very ghostly place, and I wanted
the greenish light to enhance this mood. I christened the place the Last House for two reasons.
It was a house I always wanted and which has now gone, and it was the last house at the end of its country lane.
In many traditional tales, the last house in the village was the home of a witch or wise woman.'*

With breathless gaze, and cheek with terror pale,
The lingering shepherd startles at the tale,
How, at deep midnight, by the moon's chill
* glance,*
Unearthly forms prolong the viewless dance;
While on each whisp'ring breeze that murmurs
* by,*
His busied fancy hears the hollow sigh.

An extra point of interest about the painting is
that there is no cue in it as to the era in which
we're seeing the scene. This could as well be,
rather than a modern view, Stonehenge the way it
appeared to its ancient users.

Not as part of the trilogy, Sudworth painted a
more orthodox view of the megalith in the picture
entitled simply *Stonehenge*. Regarding it, she says:

> *I decided to paint the scene showing the sun
> rising behind the stones. The midsummer sunrise
> would probably be slightly more to the right
> of the picture, as on that day the sun is said*

SLEEPING CASTLE (1998)
55CM X 92CM (22IN X 36IN)

*'Leap Castle in Ireland is particularly beautiful, and I used its basic structure
for my fairy-tale castle. Also, it is supposed to be one of the most haunted castles
in Ireland: its perceived air of menace and foreboding is so strong that it disturbs
some of the local people, and there are many reported sightings of ghosts.
Leap Castle is not surrounded by a forest as my castle is. I created my forest
using many different shapes of tree, but I particularly wanted to include the silver
birch – the Lady of the Forest, as it is known. The silver birch
is a very fairy-tale kind of tree.'*

*to rise directly over the famous heel stone as
you look from the centre of the circle. The heel
stone in the painting is barely visible, although
you can see it in the distance, to the left of the
trilithon on the right of the picture. The tallest of
the trilithons stands out in the centre of the scene;
its lintel fell long ago, but we can still see part of
the tenon joint that held it in place.*

The building of Stonehenge was an astonishing
achievement, bearing in mind the primitive tech-
nology available to our ancestors. Most megaliths
were more modest, and one such is *Castlerigg
Stone Circle* (see page 77), the second in the *Stone
Temple Trilogy*. Yet there is every bit as much
atmospheric mystery about even a less grandiose
edifice like this one, perhaps in large part in
Castlerigg's case because of the bleakness of the
surroundings. It is as if the objects of the natural
environment, too, respect this place as spiritual
and accordingly keep their distance.

That is not an entirely playful remark. There's a
curious tale that Sudworth passes on concerning
this picture. She had not been particularly keen to
sell it, but it was snapped up instantly when it was
put on show. Fortunately the buyers were friends of
hers, one of whom recounted what happened when

*some years ago she was camping beside
Castlerigg with a couple of friends. During the
night, the sheep in the field came in turn and
stood in front of one of the central stones, which
seemed to her and her friends to resemble a
human head. She said that it was a most eerie
and unnerving experience.*

The third painting in Sudworth's *Stone Temple
Trilogy* is *Long Meg and Her Daughters* (see page
78). The megalith is one of the largest stone
circles in the British Isles, being about 360ft
(110m) across, with Long Meg, the tallest of the
stones and set apart from the rest, standing about

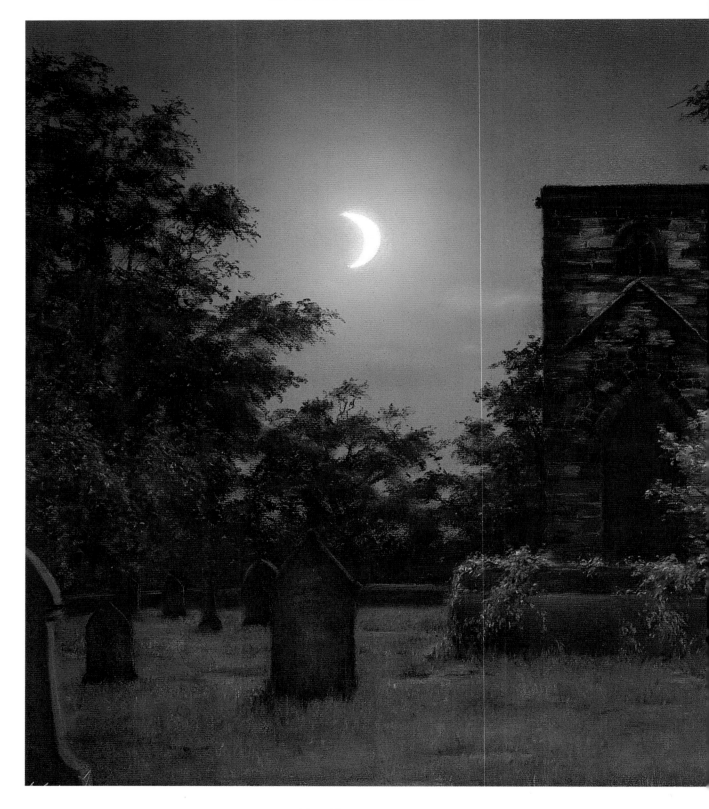

THE TOWER (1993)

49CM X 66CM (19IN X 26IN)

'Ancient places often have a very powerful feel. They are charged with the energy of past lives and events that have taken place in them. This old graveyard near where I live is no exception. It's a very peaceful place, but there is always a feeling [around] that we cannot see all that is there.'

12ft (3.7m) high. The name of the circle comes from an old story of a saint turning a coven of witches into stone. Whether or not the legend influenced Sudworth as she painted, there can be no doubt that this is a startlingly uncanny picture.

Brigida's Valley (see page 79) shows a return to the fantasy of – and indeed many of the colour values of – *Sanctuary*. With our eyes drawn to the sun brooding in the somewhat hostile sky, and to the lonely silence of the isolated valley, it may be a little while before we notice the castle on the left. The inspiration for this picture came from a legend, as Sudworth explains:

> *The legend of Brigida's valley was told to me years ago, and I have always remembered it. It tells how an immortal woman, Brigida, took a human lover. He went on a journey and never came home. So she had a castle built for herself on a hillside overlooking a wide valley where she could watch for her lover's return. She kept the valley under a cloud and forbade the sun to shine over her domain until her lover returned home.*

And return home, of course, he never did: either he fell prey to the dangers of the journey or his heart was captured by another. The sense of Brigida's anguished desolation at the seeming desertion is very strong in this picture which, although painted predominantly in red colours, has something of the chill of blue about it. It is, although the degree to which this is true is perhaps not at first obvious, one of the moodiest of Sudworth's paintings.

Also intensely moody is *The Last House* (see page 80), but here the effect of the prevailing sombreness is more immediate because of Sudworth's choice of colours – deeply evocative greens and browns – and because of the painting's overall darkness. The house itself is based on a real place:

> The Last House *is* my *picture. It is based upon a place I fell in love with as a child and explored with my sister. It was an old farmhouse, which lay just on the other side of the lane from the stables where I now keep my horse. The house had been deserted for many years and all the windows were boarded up. It had all its original outbuildings, and the old courtyard was cobbled. On many occasions, my sister and I managed to get inside the house and have a look round. We found owls nesting in the hall. The*

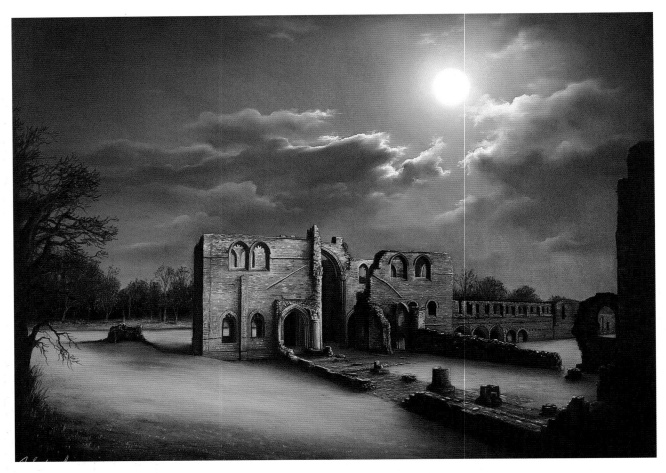

FURNESS ABBEY (1998)

56CM X 76CM (22IN X 30IN)

'Furness Abbey is a vast place. It was built by Cistercian monks in about 1100 and was added to in later centuries, until its final demise in 1537 with Henry VIII's dissolution of the monasteries. It is brimming with history and greatly inspired me. I found it hard to decide which angle to paint it from, but ultimately chose this one, to capture the impressive central arch.'

ceilings were very low, with wonderful old beams. Upstairs, many of the rooms still had old paper on the walls. The outbuildings were amazing, too. The barn roof was coming down, so we had to be careful when we went in there. But the whole place had this wonderful, magical atmosphere. It was eerie, but pleasant, and we always wanted to stay there.

The setting is beautifully fantasticated, and the same is true for that of *Sleeping Castle* (see page 81). Here, once again, the structure itself is based on a real edifice – Leap Castle in Ireland. For some while, Sudworth had wanted to paint a castle not as a fortress or stronghold, but as somewhere that would be at home in a fairy tale. She had, as a child, always loved the story of Sleeping Beauty, and so she decided to do the painting with this tale in mind:

I wanted to capture the stillness and silence of a sleeping castle, surrounded by a thick forest. I tried to create an atmosphere that suggested enchantment and magic, as though the whole place had been put under a spell.

As almost always with her paintings, what catches the eye first is the light – in this instance, the brightness of the night sky behind the brooding castle. It's almost as if the flaring light was spiritual – the sky spirit, perhaps, of which the castle is an earthly manifestation – and this impression is bolstered by the fact that the face of the castle is illuminated by some other

WAYLAND'S SMITHY (1997)

65CM X 46CM (26IN X 18IN)

'The whole scene is very misty. I wanted the background to be almost lost so that only the trees and the stones were visible.'

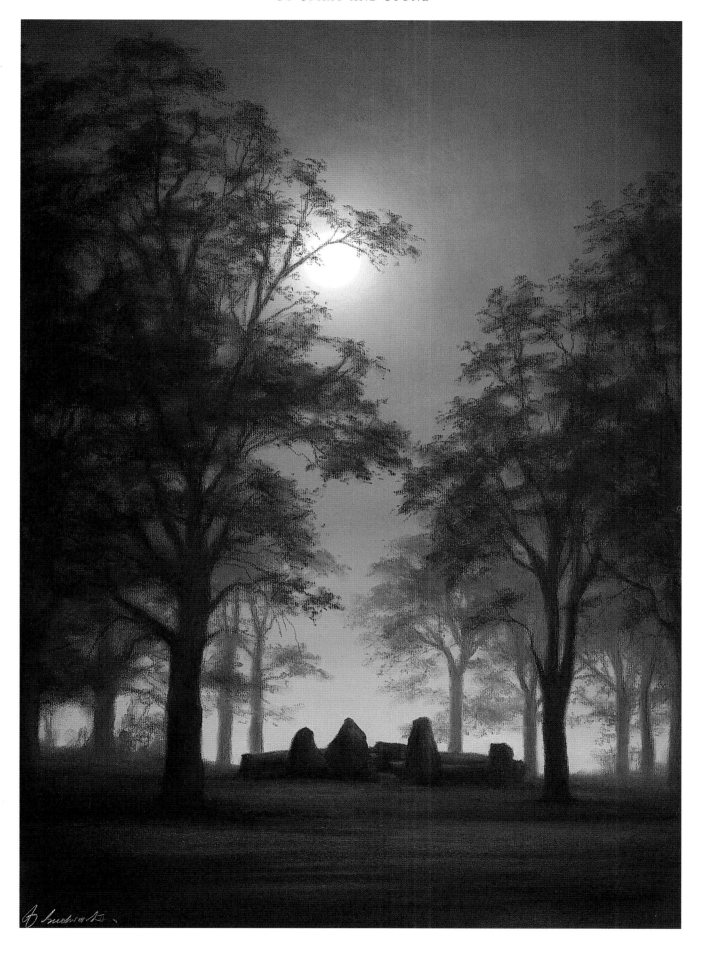

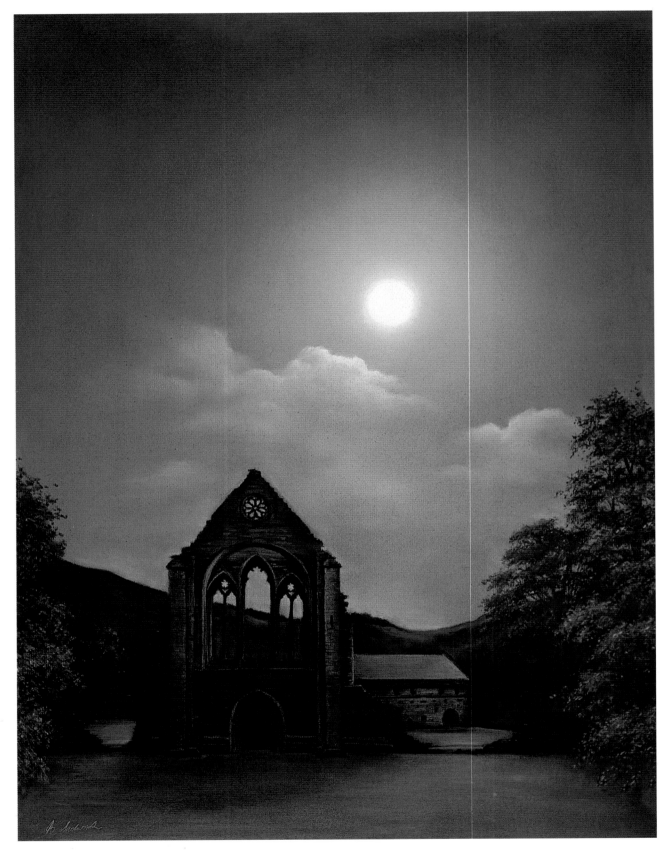

THE ABBEY (1993)
71CM X 53CM (28IN X 21IN)

'The Valle Crucis Abbey was a Cistercian monastery, founded in 1201 by the Prince of Powys. "Valle crucis"
means "valley of the cross", and quite near to the abbey are the remains of the cross it was named after. The cross
was erected in memory of a prince who ruled in the eighth century. Sadly, not a great deal of it remains.'

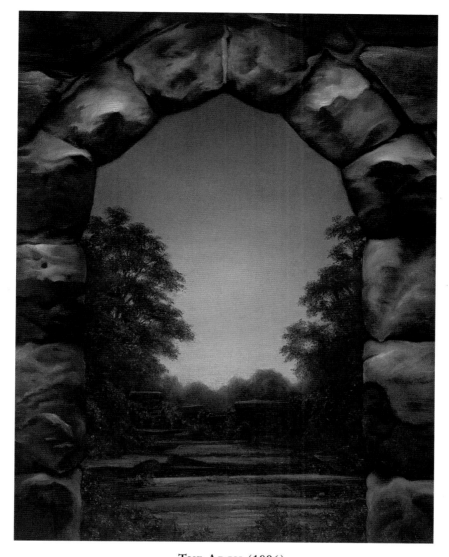

THE ARCH (1996)

148CM X 90CM (58IN X 35IN)

*'This is perhaps my largest picture. I wanted the stones to be almost life-size, so that I could stand
in front of the arch and feel as though I could actually look out into the scene beyond.'*

light-source behind us, presumably the moon.
The trees to either side seem to be pointing
towards the castle – or towards the light beyond –
in an attitude of obeisance.

Complementing this painting, and again pro-
jecting a fairy-tale atmosphere, is *The Castle* (see
page 70). Here there is no speculation about the
nature of the illumination: the source is the full
moon, riding proud in the night sky. Unlike the
building in *Sleeping Castle*, this one is definitely a
fortress, its position on a rock pillar and its
evident solidity giving it an air of impregnability.
There is also something menacing about the
castle – and something very primeval too. The
vegetation growing up the sides of the crag is
like the moss on an ancient wall. The mood is

continued by another very dark, atmospheric
painting, *The Tower* (see page 82), whose scene is
loosely based on a ruin in a very old graveyard
near Sudworth's home.

Also based on a real place is *Wayland's Smithy*
(see page 85). The legend of Wayland (or Weland)
Smith is well known from Teutonic mythology.
He offended King Nithud by marrying a swan
maiden, and as a punishment he was hamstrung,
banished to an island and forced to work as a
smith. For revenge, he slew the king's two young
sons and sent to Nithud drinking vessels made
from their skulls; to their sister, Bodvild, breast
ornaments made from their teeth; and to their
mother jewels made from their eyes. Later, not
knowing the origins of these ghastly gifts,

Bodvild brought Wayland her ring to mend – in fact, it had been stolen from him by Nithud and then given to her – and Wayland raped her and made his escape using wings of his own device.

All over Britain and parts of mainland Europe, you can come across structures that are called Wayland's Smithies. Here, so the legend ran, you could leave your horse and a few coins for a couple of hours or overnight and, so long as you made no attempt to see the smith and his hideously scarred face, you would find your horse reshod. There is a memorable episode based on this legend in Sir Walter Scott's novel *Guy Mannering* (1815). Wayland was also the smith who crafted the armour in which Beowulf fought Grendel.

The best known of Wayland's Smithies is the one depicted here, near Oxford. It is, in fact, part of a chambered long barrow or burial chamber, thought to have been built around 3500BC. The name dates back to the tenth century. The picture is an extremely striking one, with a luminous sky done in greys, greens and blues, and the monument sinisterly silhouetted in front of it. It's worth paying special attention to the trees when looking at this picture: they're charming.

Furness Abbey (see page 84), by contrast, is more or less a straightforward portrait of a place. Sudworth says:

> *This is perhaps one of the most enchanting ruins I have ever visited. Friends Barry and Jacky Martin, knowing my love of ruins and old buildings, had told me it was a most wonderful place. Neither their descriptions nor the pictures I'd seen could do justice to the real thing!*
>
> *I had to depict it in moonlight. My only regret was that, from this particular angle, I couldn't see any of the many ancient yew trees surrounding the abbey. Perhaps I will use some of those yew trees in a later painting.*

The Arch (see page 87) is one of those apparently simple paintings that has a very complicated effect on viewers. Sudworth tells how different people have reported wildly contrasting reactions to it. Some, like myself, feel a tremendous urge to walk through the archway to explore the terrain beyond; to such viewers, it is a tremendously dynamic picture, enforcing a sense of motion and of stories yet untold. Others, by contrast, find it exerts a soothing, calming influence on them;

they spend a long time in front of it, staring through the archway into the otherland, their thoughts cooled, as it were, by the tranquillity they perceive. Yet others, including the artist's own mother (which must be a bitter pill for Sudworth to swallow!), say that the picture makes them uncomfortable – to the point where they really would rather not look at it at all. Perhaps they're put off by the seeming dourness of the colours.

On a technical point, observant viewers have remarked that the archway itself has no keystone. In fact, Sudworth based it on sketches she did of an archway at Windle Abbey, which indeed lacks a keystone.

As with *Furness Abbey*, *The Abbey* (see page 86) was the product of a visit – one of the many which, as we have seen, Sudworth makes to ancient sites in search of inspiration. The result is a very calm picture, with the cool greys and pale blues of the moonlit sky filling about two-thirds of the canvas. About it, Sudworth says:

> *I went to Llangollen in Wales and discovered the ruins of the Valle Crucis Abbey. The abbey was such an atmospheric place, very haunting and exceedingly beautiful – I could almost hear the plainchant. I went back to see it a couple of times because it was so inspiring.*
>
> *After my first visit, I decided to do a picture of the abbey, and felt it should be portrayed by moonlight, not just because it's a light I particularly like but because I thought in this case the ruins would be enhanced by moonlight, and vice versa – they just seemed to go together. The only clear detail is in the top part of the window tracery, which is almost silhouetted. I wanted* The Abbey *to be a very moody picture, yet very quiet, and felt that the more understated the fine detail the better.*

THE KEEP (1996)
46CM X 69CM (18IN X 27IN)

*'The Keep is a very special picture for me. Although it doesn't depict a real place, the inspiration
for it came from a tower that I visited.'*

And finally, in a return to straightforward fantasy, there is one more astonishing picture before we end our excursion around the sites of Anne Sudworth's mental archaeology. This amazingly evocative painting is *The Keep* (see above). There is drama here, to be sure, but what most impresses is the ultimate loneliness of this brave little fortress, jutting up defiantly from its isolated rock, silhouetted against a gleaming sky that seems to offer it no companionship.

The picture holds particular personal associations for the artist:

A couple of years ago, I was under quite a lot of pressure, and one evening Warren took me to Rivington Pike, in Lancashire, once the estate of Lord Lever. The grounds are wild and untended, and the house is long gone, having been burned down in the early part of the twentieth century.

On this particular evening, a full moon gave off such a strong light that we were able to see our way quite clearly. After walking for about an hour, we reached the Pigeon Tower, a folly on top of the hill in the grounds. It was so magical and peaceful there that it recharged my energy and relieved a great deal of the stress I'd been feeling. A month or so later, I started working on this picture. It isn't of the Pigeon Tower particularly, but was simply inspired by that moonlit walk.

It seems strange that a folly, of all architectural structures, should give rise to such a major painting. And major it is, whether we look at it simply as an object of very considerable beauty or, as I do, regard it as a very potent generator of the poignancy that can define the greatest fantasy art. *The Keep* is one of a kind.

OF VISIONS AND VIEWS

ALTHOUGH ANNE SUDWORTH is a fantasy painter, she has, as noted earlier, largely steered clear of genre work. Her fantasies are of her own creation, relating more to her own worldview than to any established corpus of other people's (often themselves second-hand) ideas. Where she has derived inspiration from sources outside herself, these have tended to be objects like trees or ruins, which people with a more pragmatic vision might see in real life as simply that: objects. But it would be misleading to imagine Sudworth as somehow

STALKING TENDER PREY (1995)
83CM X 55CM (33IN X 22IN)
'In the book, Orion is a celestial gateway to the source of creation. For the purposes of the cover, I painted it below the moon; such a situation would never be seen in reality, but it was important the constellation appeared in the picture.'

living in a cocoon of her own ideas, isolated from those around her. In the course of her work and her social life, she meets and interacts with numerous people who are involved, sometimes deeply involved, in the art and literature of the imagination.

One of these people is cult fantasy/science fiction novelist and long-time friend Storm Constantine. It is on her behalf that Sudworth has four times entered the illustration arena, painting covers for Constantine's novels *Stalking Tender Prey* (1995), *Scenting Hallowed Blood* (1996), *Stealing Sacred Fire* (1997) and *Sea Dragon Heir* (1999).[11] The first three of these form Constantine's *Grigori* trilogy, which centres on the fallen angel Shemyaza – originally present as a human, Peverel Othman – and his casting off of human guise to fulfil his own destiny and that of his kind. Though based largely on ancient legends, the novels are very Gothic in tone, and the central character likewise.

All four of the illustrations can be seen as joint endeavours between artist and author, although of course the vision and the execution are uniquely Sudworth's own. Her explanations of the creative processes involved in these paintings are fascinating. *Stalking Tender Prey* (see left and opposite):

Storm [Constantine] and I were able to spend several evenings swapping ideas. When we had a rough idea of what we wanted on the cover, I did some sketches. They all showed the main character, Peverel Othman, in different poses. Storm and I decided that it would be best to have him facing away from the viewer, so that we only partially see his face – he is, after all, a man of mystery. I needed a model whose appearance fitted the description in Storm's books: someone tall, with fair hair. My partner, Warren [Hudson], fitted this role completely, and agreed to pose for the picture.

STEALING SACRED FIRE (1997)
83CM X 55CM (33IN X 22IN)
*'As in the other two paintings, we again used the
semi-profile view of Shemyaza.'*

Regarding *Scenting Hallowed Blood* (see opposite),
Sudworth says:

*In this picture, I painted the moon as full,
symbolizing a further stage in Shemyaza's devel-
opment. The moon in the first picture is waxing,
signifying his beginning, whereas the full moon
shows him in complete possession of his powers.
Warren was again the model for the picture,
though this time in different attire. In Storm's
book, Shemyaza has a ceremonial robe of
feathers. He also has a headdress made of
peacock feathers. Storm obtained some peacock
feathers for me and I made a copy of the head-
dress for Warren to wear. For the cloak, I put an
ordinary black shawl around Warren's shoulders
and painted imaginary feathers on it. I studied
feathers extensively and made many preliminary
drawings in order to depict the cloak as I
thought it would have appeared.*

And *Stealing Sacred Fire* (see left):

*This is more a symbolic representation of
Shemyaza's story, because we wanted the
Egyptian theme to be illustrated: in the book,
Shemyaza's experience of Egypt takes place
mainly underground, not above ground, as in
the picture. I depicted the different artefacts and
monuments, such as the sword and the Sphinx,
which were integral to the story. Storm and I
agreed that the figure should wear a white robe
and be kneeling to represent his state of mind by
the conclusion of the novel. Warren posed for the
piece again, and this time I made the white robe
from a large bolt of cotton. We borrowed the
same sword that I used in the painting of* The
Lair *[see page 48]. I painted most of it in the
studio and, while Warren knelt holding the
sword, I positioned large spotlights behind him
so that they shone through the cloth. This picked
out the intricate details of the folds and imitated
the light of the sun. I decided to depict a sunset
in the background, so that the strongest light
would be level with the horizon and therefore
near the figure.*

There is something very theatrical about all three
paintings, particularly *Scenting Hallowed Blood*,
and of course – at least on the above-mentioned
first two – a Gothic influence is accented. The
background of the first, *Stalking Tender Prey* – to
my mind the most successful of the trio – is of
particular interest, being very Sudworth. There is
a path along which Othman must go in order to
attain his preordained destiny, but, for the
moment, he is content merely to regard it, arms
folded, as he puts off taking the initial step
towards the first and immediate stage of his epic
journey. This is to the village of Little Moor (from
the novel), visible in the cleft of the valley just in
front of the setting sun. In *Scenting Hallowed
Blood* the setting for the figure is plainer, but the
crags to either side of Othman's/Shemyaza's out-
stretched arms, especially the one on the left, are
beautifully done. *Stealing Sacred Fire* is very dif-
ferent from the other two paintings, as befits the

SCENTING HALLOWED BLOOD (1996)
83CM X 55CM (33IN X 22IN)
*'Storm and I decided we wanted to maintain the semi-profile
view of the main character, as seen on the cover of* Stalking
Tender Prey. *This time, though, I moved him to the other side
of the picture so that the two covers didn't appear too similar.'*

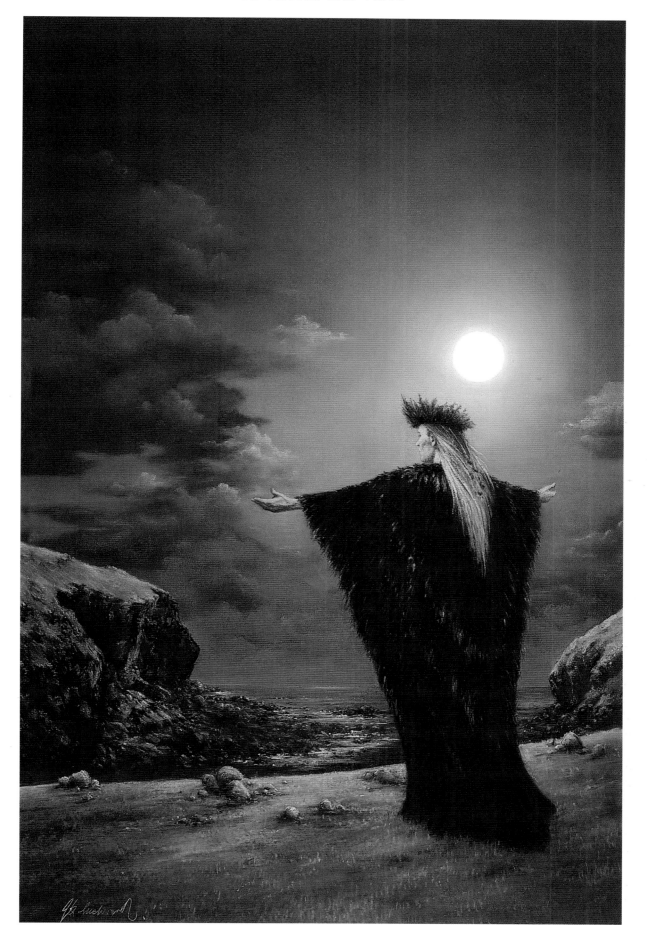

marked shift in the tale's locale. Its colours represent the most obvious of its differences, while the background details are hazier, almost Impressionist, so that, for all their evident physical massiveness, they at the same time carry the affect of the spectral. There is something Christ-like about the kneeling figure – naturally, because he is in effect the Messiah of the race of fallen angels.

While looking at the paintings for the *Grigori* trilogy one tends to be conscious that these are cover illustrations. By contrast *Sea Dragon Heir* is an enchanting piece of work by any standard. Although, like any cover illustration, its composition is governed to a large extent by the need to leave areas relatively clear for the superimposition of type, Sudworth has handled this aspect with such skill that it's hard to credit she had any such considerations in mind at all. The patterns of the edges of the natural arches, framing the brightly moonlit sky, are so strong that they seem an essential mainstay of a composition that is entire in itself – as if the picture were a stand-alone painting, and had *always* been designed to be that way. The fact that the young woman is gazing through an aperture at the magic of the arriving sea dragon adds to the painting's allure, both

SEA DRAGON HEIR (1998)
76CM X 81CM (30IN X 32IN)
'*The landscape was described as being very similar to Cornwall, with many caves and cliffs around the shoreline. I decided the dragon should be the centre of the scene, watched by one of the main characters. I had originally intended the cliffs on the left of the pillar to wrap round the back of the book. The publishers decided to use more of the centre of the scene and so the cave doesn't actually appear on the book cover. I don't really do book covers, most of my work being for galleries. But every so often it's an interesting experience.*'

94

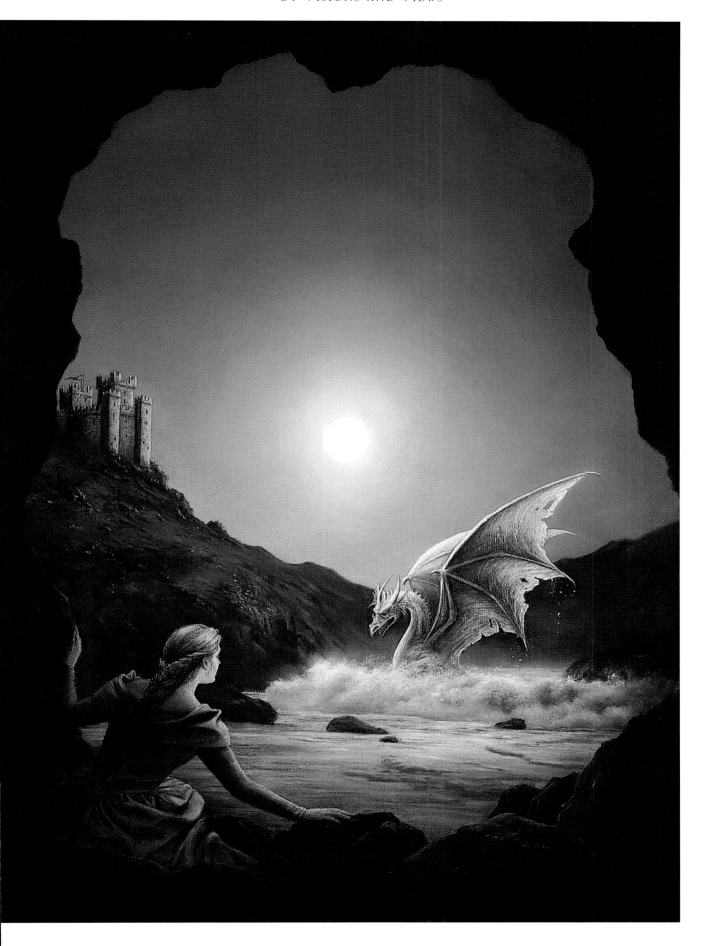

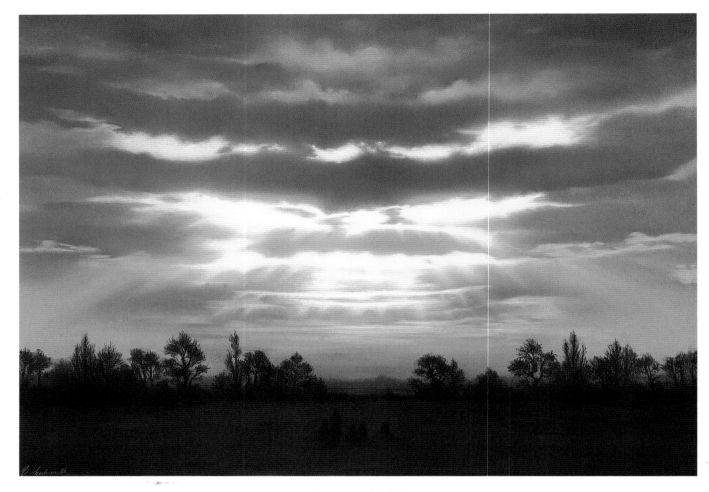

SAMHAIN (1992)
51CM X 69CM (20IN X 27IN)
*'The sky dominates almost the whole of my picture. I wanted it to represent the autumn.
I felt that the sun setting would have more of an autumnal feel.'*

drawing us into the scene and making us identify with the woman and feel her sense of wonder. As we saw in an earlier chapter, Sudworth herself has always been fascinated by and drawn to dragons, and in this picture her love for these mythical creatures clearly shows. The result is that there is something almost visionary about this painting – not a description one is accustomed to applying to a cover illustration.

Yet more visionary are a couple of paintings she has done to honour two of the major Celtic fire festivals, *Samhain* and *Lammas.* Of these two festivals, Samhain, October 31, the Celtic New Year, still survives to this day in the guise of Halloween, and, in a slightly different way, on the following day, November 1, as the Catholic Church's festival of All Saints' Day. The latter was originally celebrated on May 13, but was moved early in the eighth century by Pope Gregory III to

November 1 in an effort to supplant the Celtic festival. Samhain proper seems traceable back at least to the Druids, who are said to have believed that the spirits of the dead roamed the world on the last day of October and thus, for the first few days of November, by way of release, they had a harvest-oriented celebration. Some of the traditional Samhain activities, notably the lighting of bonfires and the wearing of masks by children (guisers), have in Britain been shifted a few days back to be associated with November 5, Guy Fawkes' Night. In Ireland, it is traditionally thought that the fairies choose Samhain as one of the three nights in the year when they are most active (the other two being May Day and Midsummer Night). As the Celtic New Year, Samhain was regarded as marking the end of one cycle and the beginning of another; it was the time when the veil between this world and the

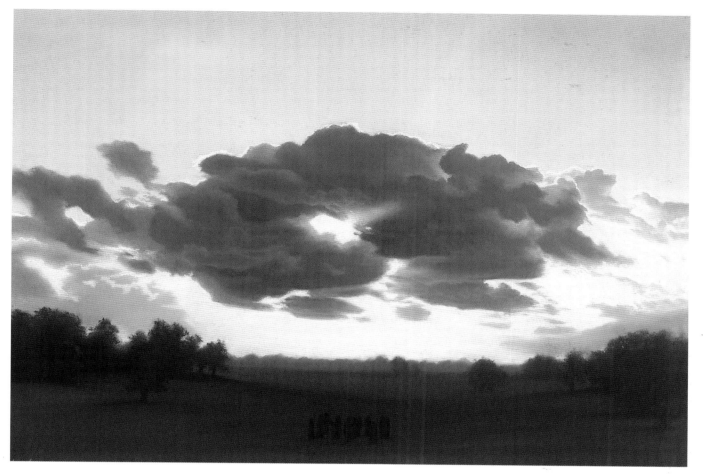

LAMMAS (1992)
47CM X 66CM (19IN X 26IN)
*'I wanted a very simple composition, which would reflect
the beauty of early morning light.'*

next was thinnest, hence the likelihood of
interaction between spirits and mortals.

There are no ghosts, witches or goblins visible
in Sudworth's *Samhain* (see opposite), yet the
imagery of this being the start of a new cycle
seems clear in this splendid cloudscape. The sun,
although at the height of its arc in the (British)
autumnal sky, gives the impression of 'dawning'
through the clouds, its fresh bright rays blessing
the land beneath. This is the same clean texture of
light that has been used in movies like *Close
Encounters of the Third Kind* (1977) to symbolize
the dawn of a new era for the human race; in
Sudworth's painting, however, there is nothing
artificial about the light – quite the contrary, it
represents spiritually the very elements of
Nature's cyclical dance.

As Samhain coincided with the ending of
the harvest, Lammas, which fell on August 1,

Overleaf:
STAY NOT ON THE PRECIPICE (1993)
50CM X 66CM (20IN X 26IN)
'The title comes from the Chaldean Oracles of Zoroaster:
*"Stay not on the precipice, with the dross of matter, for there is
a place for thine image in a realm ever splendid." This tells us
we should not be afraid of dying and leaving this world, for
there is a better place waiting for us.'*

97

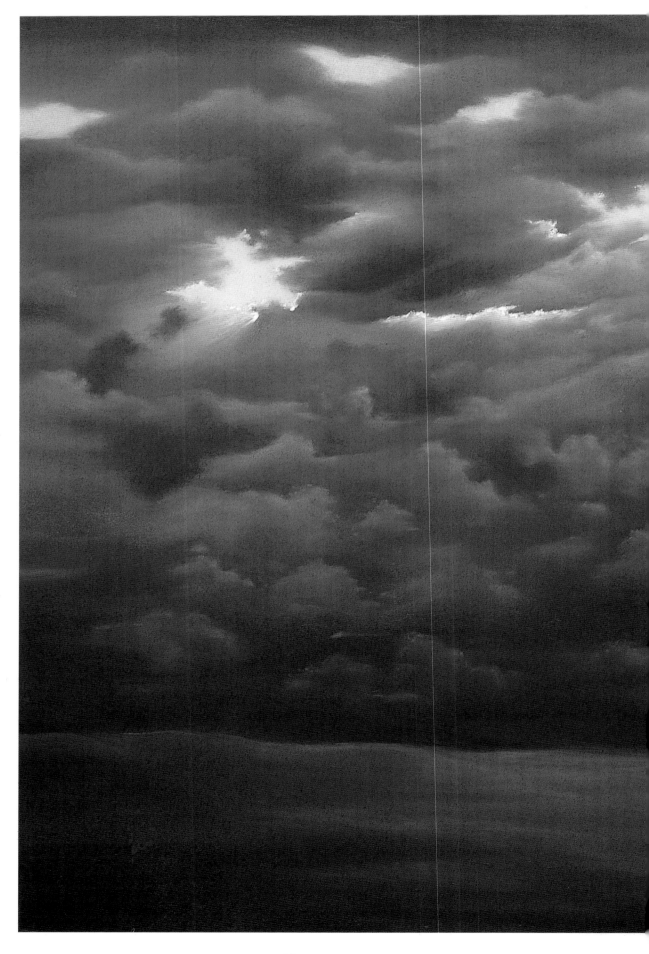

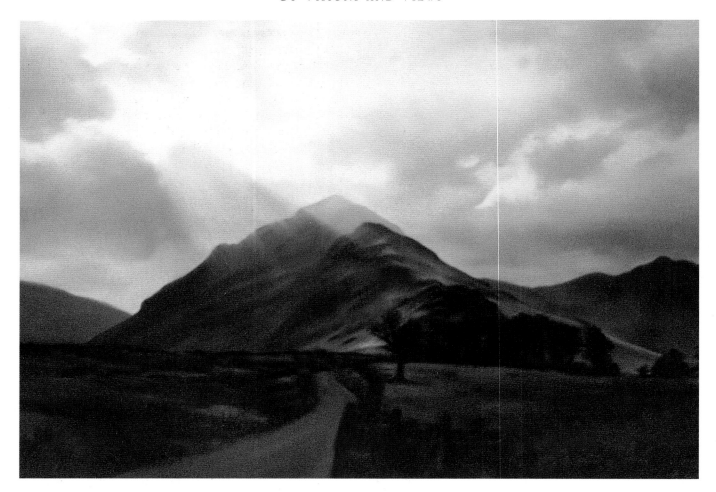

FLEETWITH PIKE (1993)
58CM X 85CM (23IN X 33IN)
'*I decided to have strong rays of light covering the peak, almost like a spotlight from the clouds. I wanted it to remain real but to have a somehow otherworldly feel.*'

intrude upon the primary focus of the picture, which is the morning sun.

signified its beginning. Again Sudworth in her painting associated with the festival, *Lammas* (see page 97), chooses not a literal representation but rather a visionary interpretation via a cloudscape:

As in Samhain, *the sky is the main feature of the painting. I wanted the picture to reflect the time of year and to have a very summery, airy feel. The clouds form an elaborate pattern around the sun. Although the sun itself isn't directly visible, it's suggested by the very bright light shining through. The horizon is very flat, without much detail. I painted a small group of figures in the centre of the land, but they do not*

Of all Sudworth's visionary cloudscapes, the most visually imposing is that in *Stay Not On the Precipice* (see page 98), where the clouds are physically massive and bear down upon the world with all the force of that mass. The title is taken from a passage in Zoroaster that relates to the transition between life and death, and the painting is, not surprisingly in that context, once again related to the Celtic festival of Samhain. Sudworth herself offers a very full description:

I used a great deal of symbolism in this piece. *The clouds take up almost the whole of the picture. Clouds themselves have always been a symbol of the division between this life and the*

next. It has been said in legends that clouds concealed the gods and provided a barrier between this world and the hereafter. Clouds have always been associated with spirits, ghosts and the otherworld. Around Samhain, on October 31, the land is often blanketed in clouds and mists – it is 'the season of mists and mellow fruitfulness', as Keats described it in his 'Ode to Autumn'. Traditionally, this was meant to be the time when the curtain was thinnest between this world and the next, and spirits were said to be able to cross back to this world hidden in the clouds.

The picture is predominantly green, symbolically a colour associated with death. The painting follows a similar theme to The Path *[see page 105]. This is a very dark and moody piece, almost menacing in a way, as the clouds seem to be rolling inexorably towards the viewer, enveloping anything in their path. And it is inevitable that we will all experience a journey through those clouds.*

At first glance, the two pictures that make up *The Candles* (see below) might seem to be simple Still

Lifes and really rather similar to each other, but in fact it soon becomes obvious that they are very different in mood. Here the two candles' individual glows relate to the natures of the two books, the first being a book of prayers and the second a book of spells, or grimoire. Sudworth's original intention was to paint a third picture, with in this case the book being a collection of fairy tales, but so far she hasn't completed this project. All extraneous details – such as furniture or a domestic background – have been excluded: Sudworth wanted the goblet, the book and of course the candle to be, as it were, intimate to the viewer, as if he or she were looking at objects on a personal desk or table. She adds: 'I love candlelight, whether it's illuminating silver, fabric or paper. It is a very spiritual and contemplative light.'

With her fantasist's eye, Sudworth is naturally able to see the mystical, spiritual or otherworldly

Left:
CANDLE 1 (1994)
61CM X 52CM (24IN X 20IN)

Above:
CANDLE 2 (1995)
66CM X 49CM (26IN X 19IN)
*'The first candlestick here, though genuine silver,
is a modern reproduction.
But the other is a very, very old one that my mother
kindly let me borrow.
Unfortunately, I had to give it back.'*

THE DARK SIDE (1998)
64CM X 88CM (25IN X 35IN)
'*Many fantasies and fairy tales involve journeys through wild and unfriendly places.*
It was partly with this in mind that I decided to create this scene.'

in candlelight but also, and even more so, in the landscapes around her. Those of her beloved Lake District are paramount among these.

In this context she has remarked of *Watendlath Bridge* (see opposite) that

> *it's one of those places that could be right out of a fairy tale. I felt it had to be portrayed by moonlight – I wanted that very soft light, when things are hardly visible, so that just odd stones and ripples on the stream can be picked out of the darkness*

and of *Fleetwith Pike* (see page 100) that

> *every artist has places that are particularly inspiring. For me, Fleetwith is one of them. I wanted to portray it as though it were enchanted in some way.*

She spells things out even more clearly in connection with *The Dark Side* (see above):

> *This picture can work on two levels. First it is quite simply a landscape, though hopefully I've captured the drama and atmosphere that I wanted in the scene. On another level, it can be interpreted symbolically as a journey into the unknown – to the dark side of the mountain where things are not always as they seem and we can easily become lost.*

Simply as evocative landscape paintings, all three are magnificent; but of course they are more than that. The subtle greys and blues (Sudworth's 'very soft light') of *Watendlath Bridge* make it seem like a place inhabited by not-unfriendly spirits who are living at tranquil ease with both the seen and the hidden world around them. The peak in *Fleetwith Pike*, with shafts of sunlight playing on

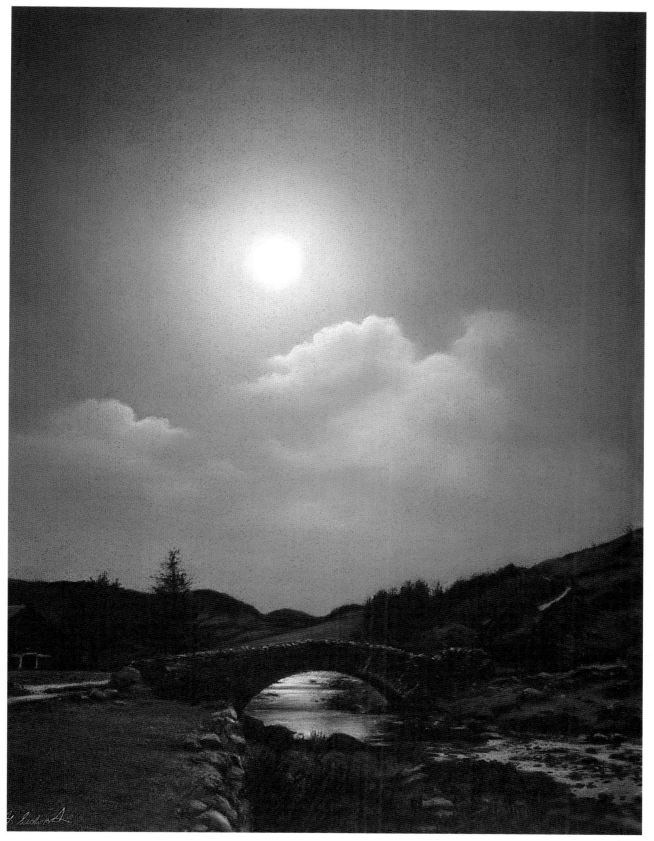

WATENDLATH BRIDGE (1994)
65CM X 84CM (26IN X 33IN)
'I was tempted to call the painting Bridge of Blood *after the bridge of that name which features in one of the old Celtic fairy tales – no one who has killed is able to cross it – but I decided this was too harsh a name for such a fairy-tale place.'*

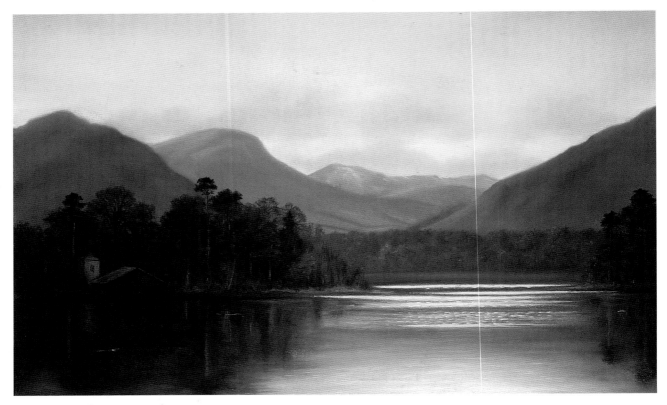

THE LADY'S LAKE (1993)

44CM X 72CM (17IN X 28IN)

'This painting is based on Derwent Water in the Lake District. It's a very magical place, surrounded by oaks and various other trees. The water always appears to be very still, with just the occasional ripple across its surface. One can almost imagine the Lady of the Lake living beneath the water.'

its slopes and making the summit seem whitely radiant, appears not only 'enchanted in some way' but also as if it were being blessed by God – as if it were some latter-day equivalent in miniature of the Bible's Mount Sinai. And, whereas the invisible spirits of *Watendlath Bridge* can be sensed instinctively to be benevolent, those of *The Darkside* come across as very sinister indeed: this gloomy pass – gloomy despite the efforts of the brightly radiant sky overhead – is, one feels, a place where one has no desire to tread.

A more specific fantasy is connected with *The Lady's Lake* (see above). The real-life lake upon which this painting is based is Derwent Water, yet again in Sudworth's cherished Lake District. It is the widest lake in modern-day Cumbria, and in its centre is a tiny island where it was traditionally thought that a group of Druidic priestesses had once made their home. Derwent Water has for centuries been associated with the legend of the Lady of the Lake, who gave King Arthur, the Once and Future King, the enchanted sword Excalibur. Later, as he lay dying, she accepted it

back again from the hand of his faithful knight Sir Bedevere. Thereafter she led the maidens who took King Arthur's body by boat off into the mists of the lake – to Avalon, and to both legendary and literary immortality. Much earlier, the Lady of the Lake had reared Lancelot from infancy after he had been taken from his parents. It would seem that two legends may have been conflated here: while Cumbria might be a likely enough locale for Lancelot's childhood, it is far north of most of the other sites traditionally and historically associated with the life of King Arthur.

THE PATH (1995)

72CM X 49CM (28IN X 19IN)

'To me, this is quite a spiritual picture. Many people have told me they find it a little unnerving, but this was not my intention. I can see why graveyards and headstones are often regarded as morbid or macabre, but in this instance the gravestones are only symbols for something we all have to go through: the journey from this life to the next.'

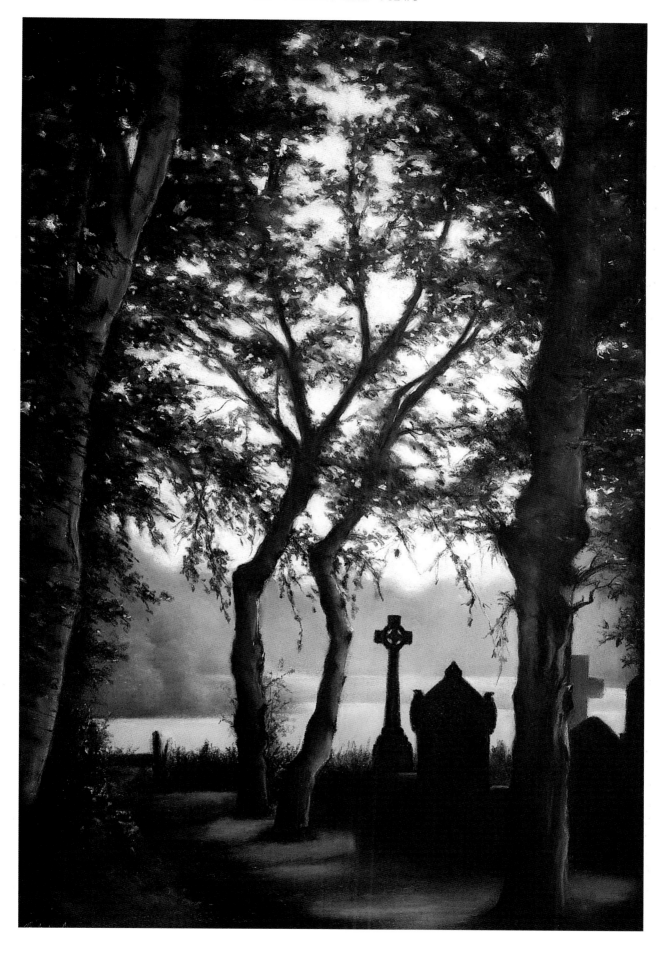

As with the last few pictures we've talked about, *The Lady's Lake* can be taken at one level as no more than a superbly executed piece of landscape painting. Yet, the longer and more carefully one looks at it, the more mystically anticipatory it becomes. It is as if all the elements of the scene – the scarcely ruffled water, the dark surrounding trees and the cloud-touched mountains – were holding their breath in expectation of some miraculous, transcendent event...perhaps the fair hand of the Lady breaking open that tranquil surface to hold the sword Excalibur aloft?

The Path (see page 105) is another picture that could be dismissed as merely a realistic depiction of a mundane scene. But there is far more to it than that, as Sudworth elaborates – once again alluding tangentially to the Arthurian legends:

Generally I paint paths that are full of light, but the one in this picture is unusually dark and in shadow; it can hardly be seen. Once the eye passes the gatepost, the light changes, becoming very soft and luminous, almost hazy. In the distance, there is a misty, summery wood, which represents life beyond this existence. The wood appears almost like an island, such as the legendary Avalon or Elysium.

Whether one regards the paradisal land beyond the reach of the physical obstacles of human existence (most especially death, as signified by the gravestones) to be the distant wood or, more immediately, the sun-strewn grasslands between them and the edge of the copse where we stand, there can be no doubt that this painting is full of the dynamism of change, of transformation from one state to another, of rite-of-passage, of transcendence. The dark cemetery and its even darker path seem heavy, as if clinging to our heels and slowing down our passage into the light. Yet there is nothing unkind or obstructive about the beautifully rendered trees – indeed, they are very graceful – nor about the headstones of the grave-yard that basks peacefully in their shade. Any impediment to our progress lies not in the physical scene but in ourselves, as does the reason for our impatience with that impediment. We are

beckoned to make the transition into the light; at one and the same time we feel no urgency to effect that transition, and are impatient to begin, to shake off the burdensome weight of our surroundings. Various people have remarked to the artist that they find *The Path* an 'unnerving' painting, and have attributed this to the fact that its ostensible subject is a graveyard, a place traditionally regarded as spooky or depressing – the ultimate *memento mori*. Yet I think this painting unsettles us because of the internal conflict we feel between our desire to move forward, to progress, and our reluctance to do so – or, at the very least, our almost dreamlike apathy about hurrying the process along.

We began this book by looking at a selection of Sudworth's tree paintings, and it seems only fitting that we should end both it and this section on Sudworth's visionary and mystical work with two pictures in which trees play such a dominant role – *The Path* and *Morning (Trees for Patricia)*. Of the latter painting, Sudworth writes:

I felt I had to end this book with a tree. It's only a very simple composition, with the tree silhouetted against a hazy, early morning sky. I wanted a slightly misty look to the scene to capture that early morning feel, when the sun hasn't quite broken through the haze.

In these two paintings,[12] there is no sign of the Earth Light that characterizes so many of Sudworth's other tree pictures, and yet we have the sense that it is there nevertheless – unpainted because it doesn't have to be shown overtly. Like the fairies in Sudworth's *The Fairy Wood* (see page 34), it is there for you to see if only you look at the painting in the right way – with, if you like, a fantasist's vision.

A fantasist's vision.

It is Anne Sudworth's great genius – and what makes her, as I maintained at the beginning, such an important fantasy painter – that she does not just possess but *gives to all of us* a fantasist's vision.

If we allow her to.

Left:

MORNING (TREES FOR PATRICIA) (1994)

48CM X 32CM (19IN X 13IN)

'*This picture was done for my friend Pat, who loves trees as much as I do.*'

APPENDIX

A *WORK* IN *PROGRESS*

The work in progress shown here is the Earth Light tree picture Ghost, *the finished version of which is on page 28. Following are various intervals in its creation. Obviously it isn't possible to show each stage from start to finish, so I've tried to pick out the main areas of change.*

1 Once I have an idea in my head, I do some very rough basic sketches – I hardly ever do detailed drawings. Sometimes these sketches are so rough it is hard for anyone but myself to tell what they are. In this study, I just set down the main shapes and colours that I wanted in the work, and where the main features would be. For most of my studies I use various colours of Canson pastel paper, though sometimes I use plain cartridge paper.

2 For the main piece of work, I chose a large piece of Ingres board. I use this for most of my pictures, usually in a warm white or cream. I generally cut the boards down so that they are about seven or eight inches wider and taller than the intended size of the picture. I always draw a rough outline of the boundary of the picture, though sometimes the painting can develop beyond the boundary. I then sketch in the basic outlines and shapes of where I want things to go. I usually do this in a neutral colour like a soft grey or brown – something I can work over later.

3 If the picture is a landscape, I always do the sky first, and often end up covering some of the sketching I have done. For *Ghost* I spent several days on the clouds and their colours. Once I was happy with the sky, I began to block in rough areas of black where the tops of the trees would be. I also highlighted the branches of the dead tree and made the skyline more defined. At this stage, I had a slight problem, because I had done more work on the sky than I had intended and couldn't decide whether (a) to leave more of it showing and have less trees or (b) to work over it and keep the trees as I had originally intended. I decided to stick to my original idea.

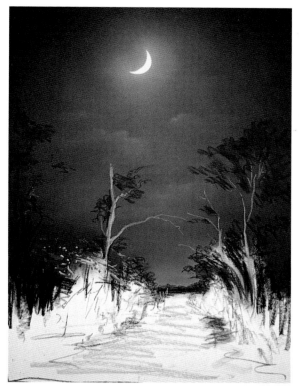

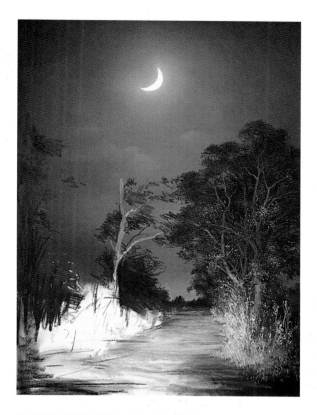

4 Once I had started to block in the trees, I began to pick out detail and clarify the shapes of branches. In this picture I worked from right to left. I built up the group of trees on the right until I was fairly happy with the shapes. I don't always finish a particular part of a picture before moving on to another, as I tend to go back and add to or change things, depending on how other areas of the picture are working.

5 Gradually, I began working on the trees nearer the centre of the picture, making them much denser. I then started to work on the left-hand side of the picture, being careful not to make the trees too dense around the dead tree. I started to build up the colour on either side of the path, using very pale colours next to the blacks and browns of the trees. I began to add details and tones to the path, making it lighter towards the centre of the picture. Once I had built up the picture in all areas, I went back over it, adding and changing again. I wanted the path to have a little more definition and the light to be a bit stronger at the bottom of the trees. I also wanted a bit more warmth and detail higher up in the branches.

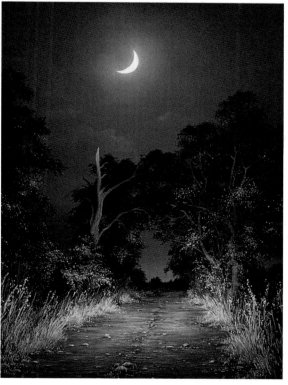

6 I usually leave a piece of work for a few days before looking at it again to see if I'm happy with it. It's hard to say when a piece is finished – one can keep working on it endlessly without getting anywhere – but usually I consider it finished simply when I'm happy with it, when I feel I've captured the feeling and atmosphere I intended.

This painting took about three weeks to complete, with occasional breaks. Some pictures take only a short time, others much longer.

NOTES

1 To a great extent this has always been true – as was amply demonstrated to me recently when a visit to the New York headquarters of the Society of Illustrators was followed by one to a 'straight' gallery (to generalize, the illustrations were artistically better than the Fine Art) – but the emphasis on illustration as the sphere in which the artist is most likely to survive has hugely increased in recent decades.

2 For this reason, their work is very often unknown or inaccessible to those interested in genre illustration – as is starkly obvious on the rare occasions when they exhibit at fantasy or science fiction conventions. A dramatic exception came at the 1999 Easter UK Science Fiction Convention when the judges of the second annual Paper Tiger Award for the best artwork on show chose Fine Art (by Tom Abba) as the winner and two (Judith Clute, Jay Hirst) of the three runners up.

It should be noted in passing that Anne Sudworth is almost unique among fantasy Fine Artists in that her work is in fact very popular at genre exhibitions.

3 *The Encyclopedia of Fantasy* (1997) edited by John Clute and John Grant; *The Encyclopedia of Fantasy and Science Fiction Art Techniques* (1996) by John Grant and Ron Tiner.

4 I am obviously ignoring straightforward narrative illustration, as in the comics, and collage-style treatments, movie posters and media tie-in book covers, etc.

5 A striking non-Sudworthian example of this motion-in-the-still is offered by Keith Scaife's cover for Charles De Lint's *The Little Country* (1991), which is to all outward appearances a Still Life.

6 Sudworth has admitted that she cheated when painting this picture: she did the landscape first, then sketched Dilly tied up in the stableyard before painting him and herself into the picture.

7 One of the working titles of this book was *The Enchanted Tree*, not just because it was a tip of the hat to the fairy picture of that name by the Victorian illustrator Richard Doyle but also as a reflection of the fact that trees, with their Earth Light, play a major part in Sudworth's own personal mythology. This subject is covered in more detail in the next chapter.

8 Another name for the alder is the fairy tree.

9 For a very funny introduction to Fantasyland and its denizens you should try *The Tough Guide to Fantasyland* (1996) by Diana Wynne Jones.

10 Indeed, this is one of the mainstay attractions of Fantasyland, the place where high-fantasy stories are set: the technology of Fantasyland is inevitably primitive so that there is plenty of room for folk to use magic instead.

11 Apart from all the other considerations, there is a very practical reason why Sudworth's book illustration work is so limited. Her paintings sell for several times more than publishers are prepared to pay for a cover picture.

12 On a technical note, works in pastel are generally referred to as paintings.

INDEX OF WORKS

ACKNOWLEDGEMENTS

First, I would like to say thank you to my Mother, Father and my sister Deborah,
for always being there and having confidence in my work.
I would also like to say a special thank you to Paul Barnett (John Grant), not just for
writing a wonderful text for this book, but also for a great deal of other work he did on
this project and for his help, humour, guidance and especially his friendship.
Many thanks as well to Liz Dean, Cameron Brown and Sonia Pugh for all their help
and hard work in producing this book and to Malcolm Couch for designing it.
Thanks also to Sara Holmes of the Grove House Gallery and to
Michael, Jane and Ian of Camera Five Four.
I would also like to thank the following people for their friendship, advice
and support: Mike, Michelle and John, Chad and Carla, Donna and James, Paul and
Rachel, Stella and Anthony, Kevin, Mike and Sue, Lynsey and Alex, Stuart, Mike and
Angie, Storm and Jim, Vikki and Steve, Arthur and Margaret, Barbara, Pat and Roger,
Barry and Jacky, Arthur, Paul Joyce, Jo Fletcher, Pam Scoville and Sylvia Starshine.
Finally my thanks go to Warren for his support, encouragement and hard work,
and for doing almost everything except the paintings.
ANNE SUDWORTH

First and foremost, I'm deeply indebted to Anne Sudworth – without whom,
obviously, this book couldn't have existed – and to Warren Hudson, who in difficult
circumstances slaved late into the night making sure my irritating questions were
swiftly and fully answered, that I had a complete set of reference copies of all the
illustrations, and much more besides. Far more important than all that, thanks
for being such dear friends, Annie and Warren.
Enchanted World could not have been brought into being had not various
people at Collins & Brown kept the faith: to try to mention all of them would
be to risk committing a sin of omission, but Liz Dean's contribution must be
singled out – many, many thanks, Liz.
My daughter, Jane Barnett, made it clear from the outset that I was to
do her friend Annie a good commentary, or else; OK, Jane, this text (good or
otherwise) is for you. Judith Clute gave her blessings and a prompt answer to a
niggling query. Monique Peterson was taken up on her generous offer to read the
text. Gary Westfahl kindly sorted out for me the situation *vis à vis*
Dorothy and the trees of Oz.
Especial thanks to my magical wife Pam Scoville who, if such a thing
were possible, would be even more of a lover of Anne's work than I am. She has
given unflagging encouragement, advice, technical assistance, support, love and
everything else, even when I've been at my grumpiest. Thanks, Pam, for *being*.
JOHN GRANT